FLORAL WONDERLAND

A Blooming Coloring Retreat

RACHEL REINERT

Get Creative 6

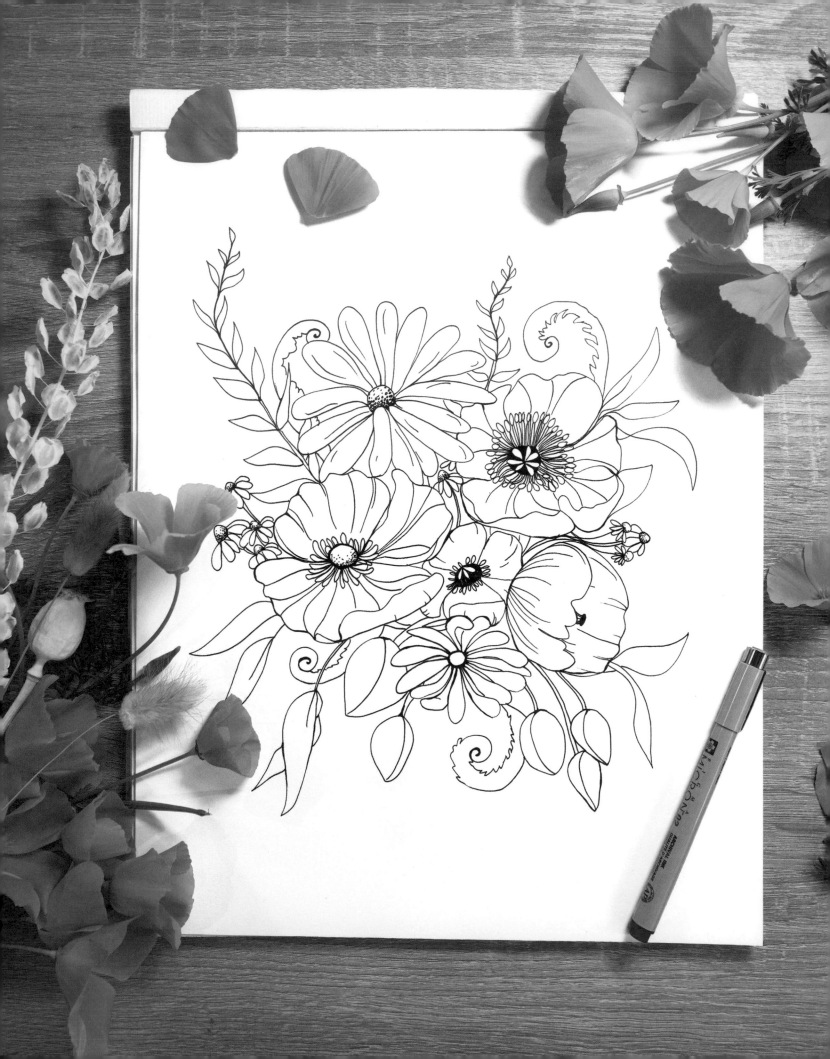

INTRODUCTION

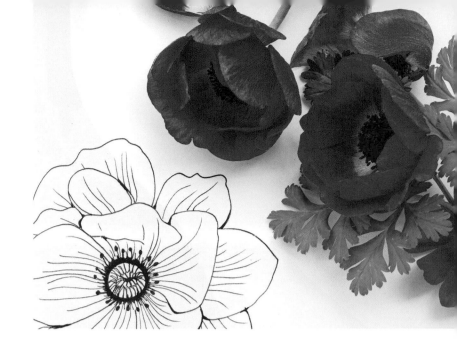

One of the most beautiful things in this world is a blooming flower. Not only is the beauty enchanting, but it's a reason to celebrate because it lasts for only a short while. From the delicate orchid to the robust protea, flowers are a symbol of new life and can be appreciated universally. Whether arranged as perfectly picked blooms for a bride, given as gifts for special occasions, used to mark anniversaries or celebrate lives of those we've lost, or even "just because," florals remind us of beauty in the world. Symbolically, we all know flowers can speak words and give meaning when there are no words. They can represent peace, eternal love, friendship, solidarity, condolences, and playfulness. They stimulate our creativity. They bring vivid color and life into a sometimes dull world, and their power is undeniable.

As a follow-up book to my how-to-draw book *In Bloom: A Step-by-Step Guide to Drawing Lush Florals*, this book is a blooming exploration of floral arrangements to color. I've included traditional floral still lifes, bountiful bouquets, uncommon wreaths, and playful terrariums. Now it's up to you to bring these blooms to life! Feel free to tear out the perforated pages and share with a friend. Better yet, plan a coloring party and see how fun and relaxing it is to color with old friends and new. It doesn't matter if you're just beginning to learn how to color or you're a professional artist — there is something here for everyone.

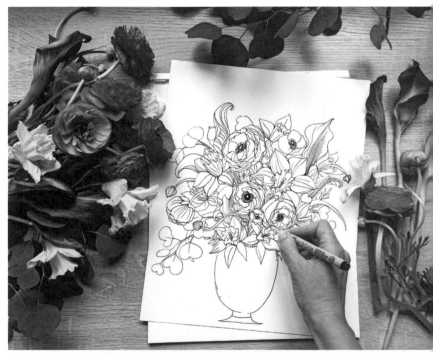

And my biggest piece of advice: Don't worry about staying in the lines or "messing up." Use this book to freely unfold your personal creativity or to relieve stress. If you don't already know the wonders that coloring can bring to your life, you'll see that it's a powerful way to help you relax, focus, and let go.

I'd especially love to see your work on these pages, so be sure to tag me on Instagram at @rachelreinertstudio!

ABOUT THE AUTHOR

Hi, I'm Rachel! I'm passionate about creating and teaching art and can be found experimenting with pour painting, drawing, and coloring in my backyard studio. After living and traveling abroad, I created my first two coloring books, *Botanical Wonderland* and *Desert Wonderland*. Currently, I live in the beautiful Pacific Northwest with my daughter, Emerald, and husband, Andrew. I like to be in nature whenever I can—it remains my biggest inspiration. I love to play with our three sweet chickens, work on my gardening skills, and take beautiful hikes in the lush forests nearby. I feel incredibly lucky and humbled to have the freedom to create and share my art with the world! My other two books on art and coloring instruction are *Color Workshop: A Step-by-Step Guide to Creating Artistic Effects* and *In Bloom: A Step-by-Step Guide to Drawing Lush Florals*. Visit my website, www.rachelreinert.com, or Instagram, @rachelreinertstudio.

Get Creative 6

An imprint of Mixed Media Resources
19 West 21st Street, Suite 601
New York, NY 10010
sixthandspringbooks.com

ISBN: 978-1-68462-042-5

Manufactured in China

3 5 7 9 10 8 6 4

First Edition

DEDICATION

This book is dedicated to all those who find joy in flowers and coloring, young and old. And to my husband, Andrew, who ceaselessly supports me on all my artistic journeys.

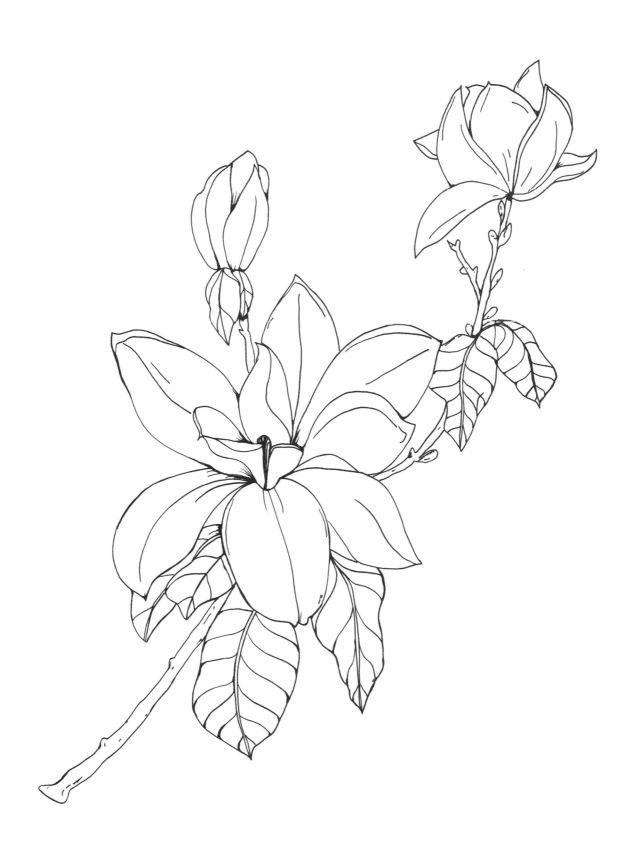

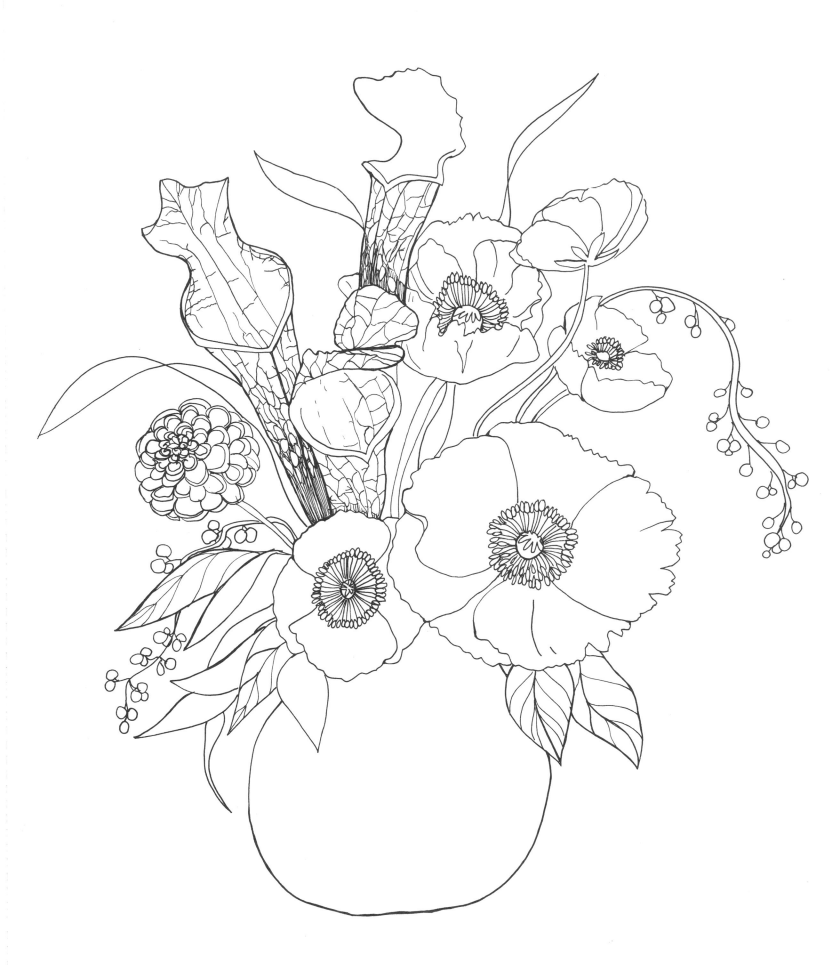

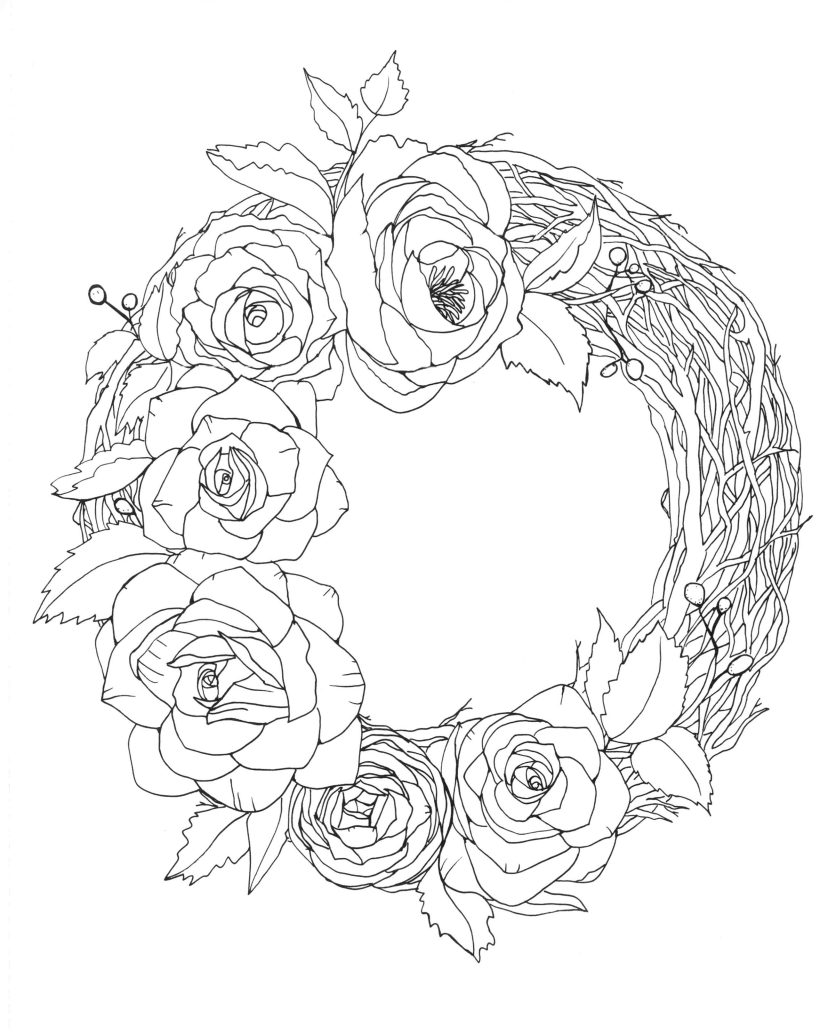

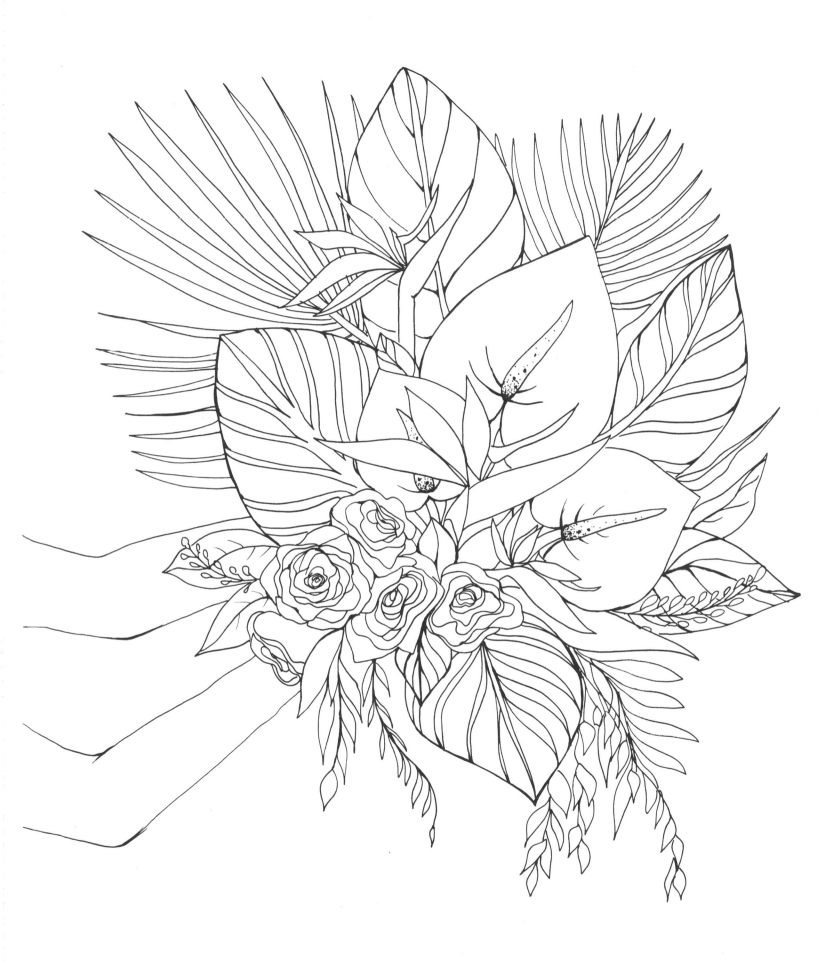

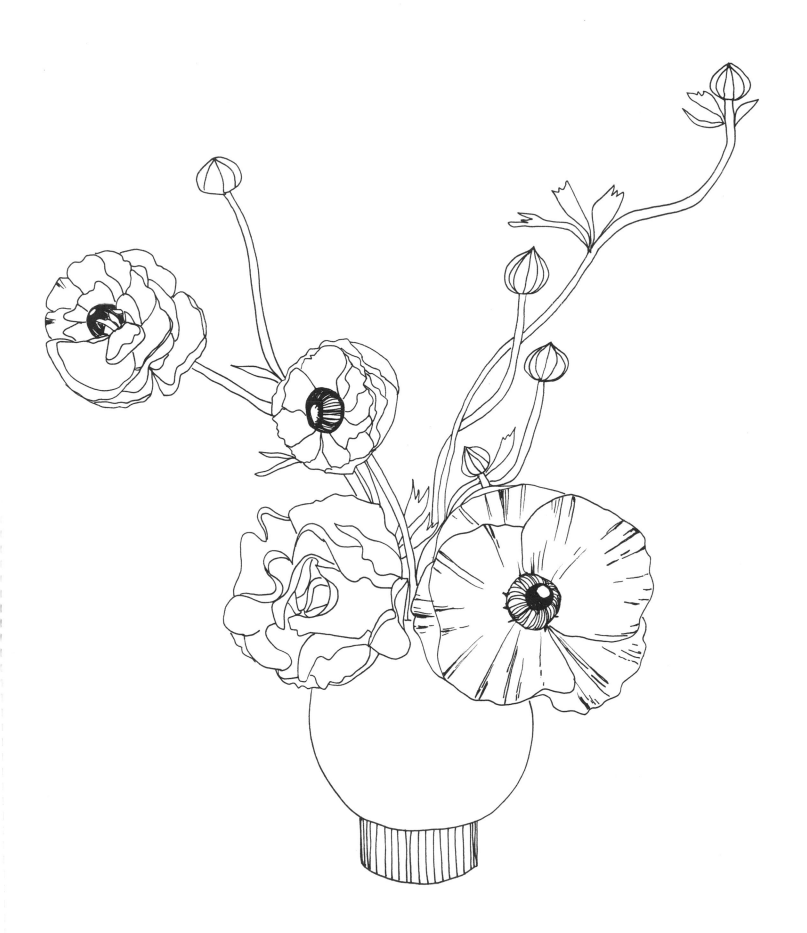

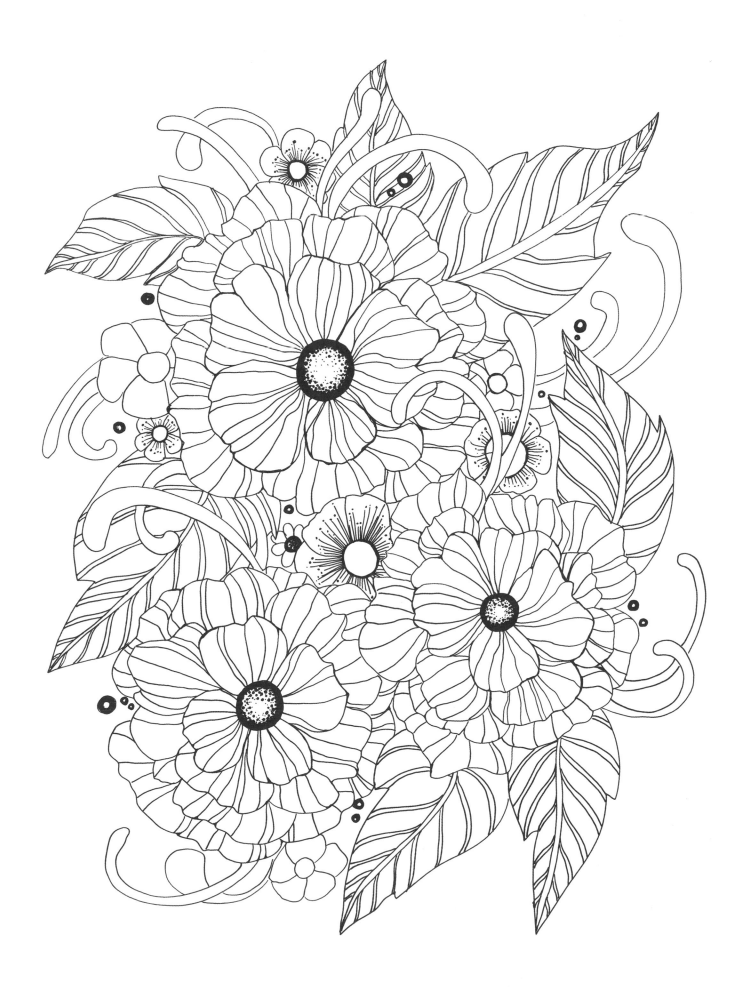

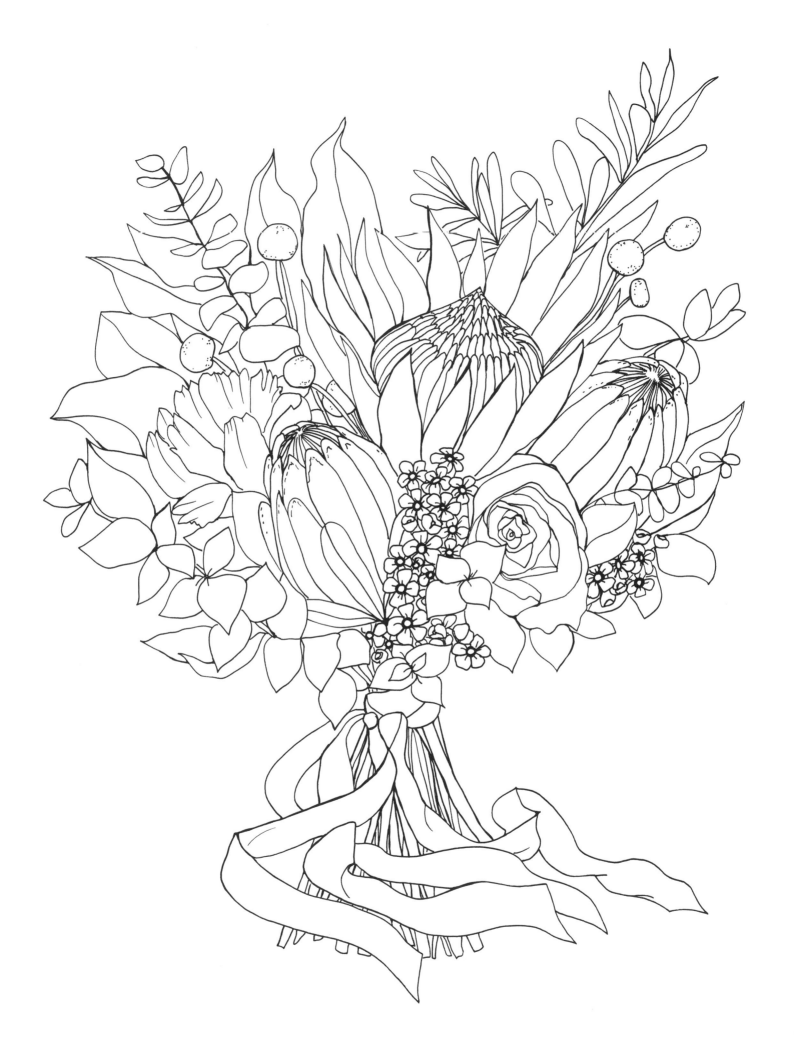

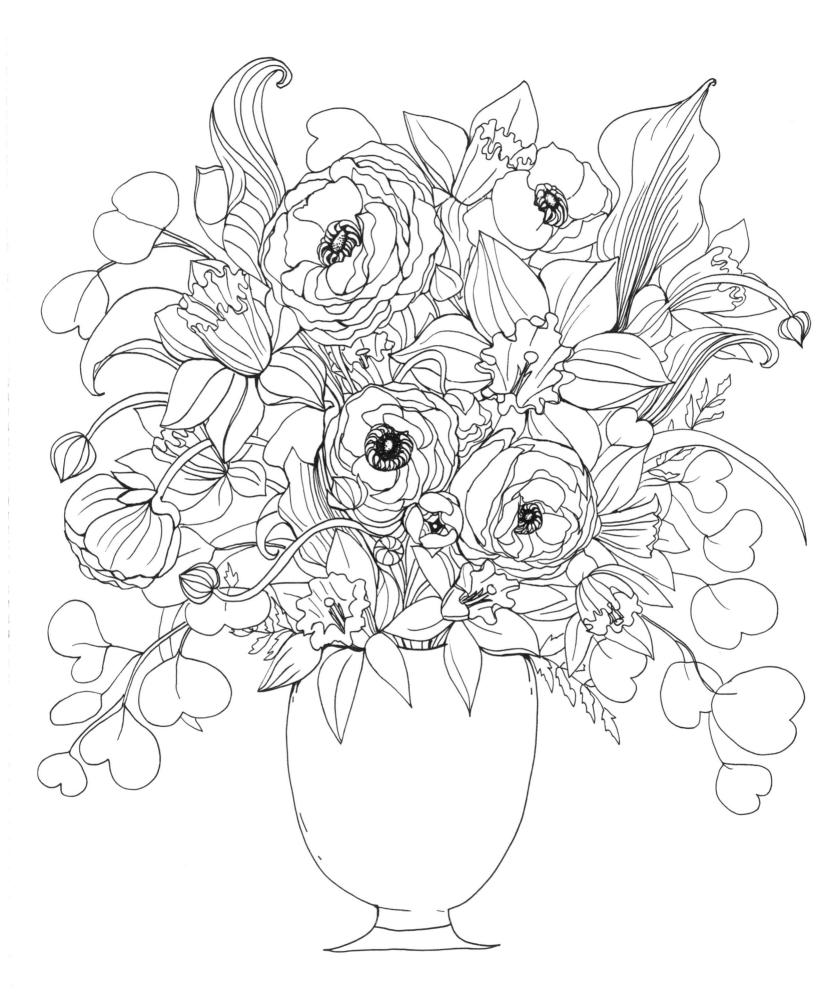

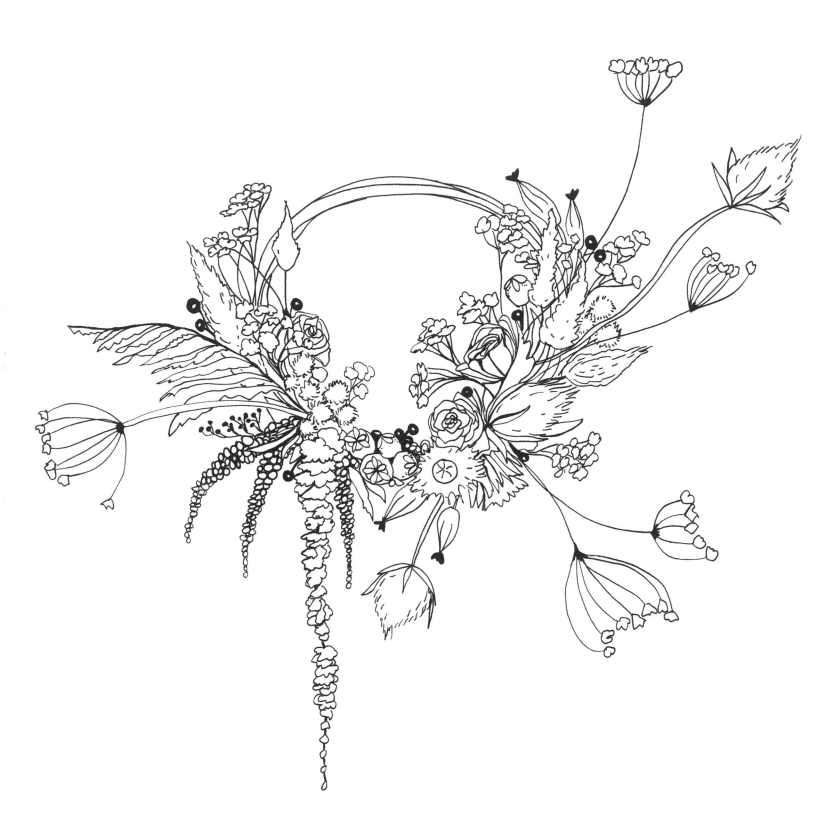

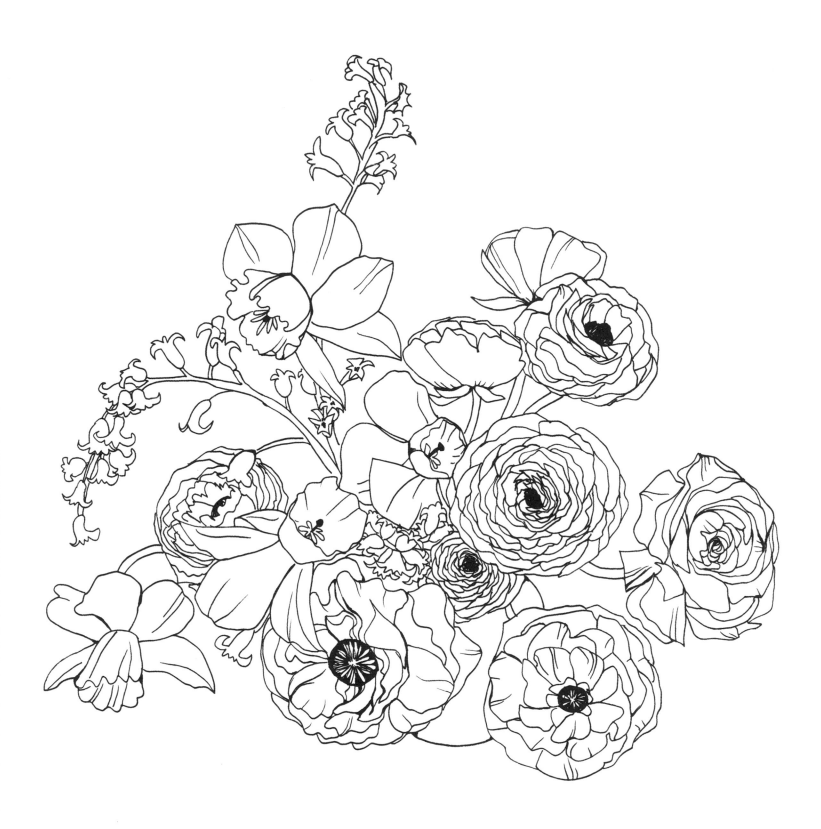

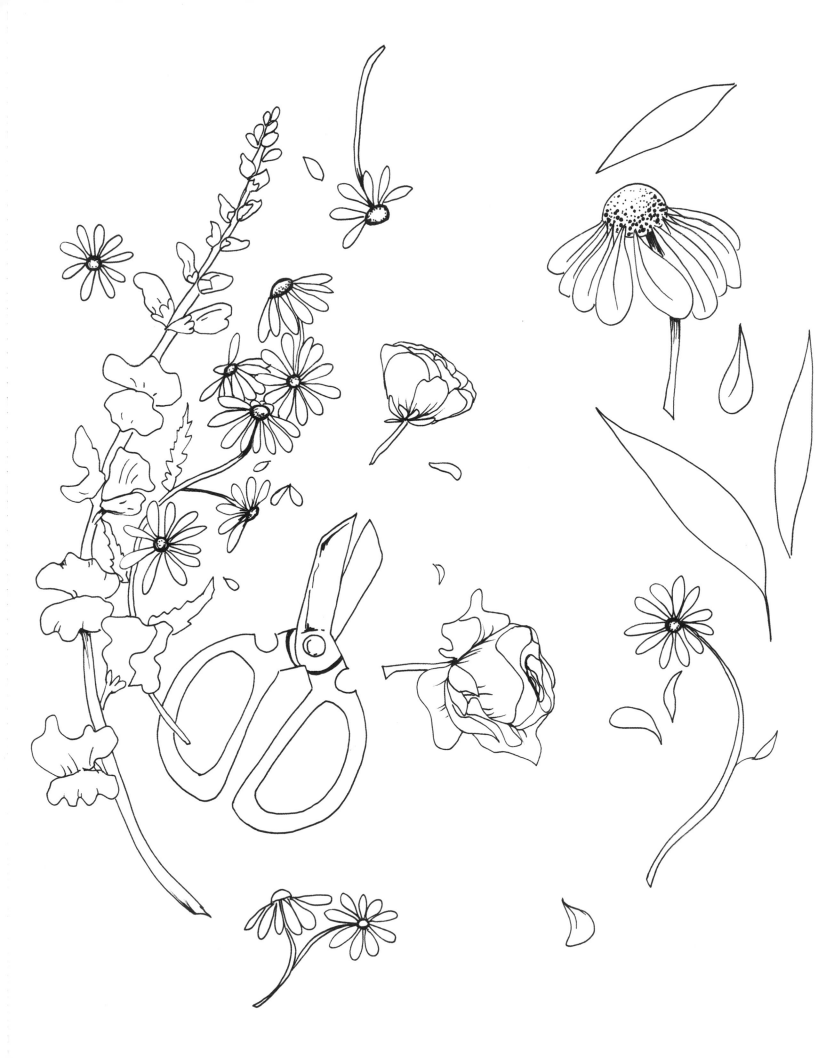

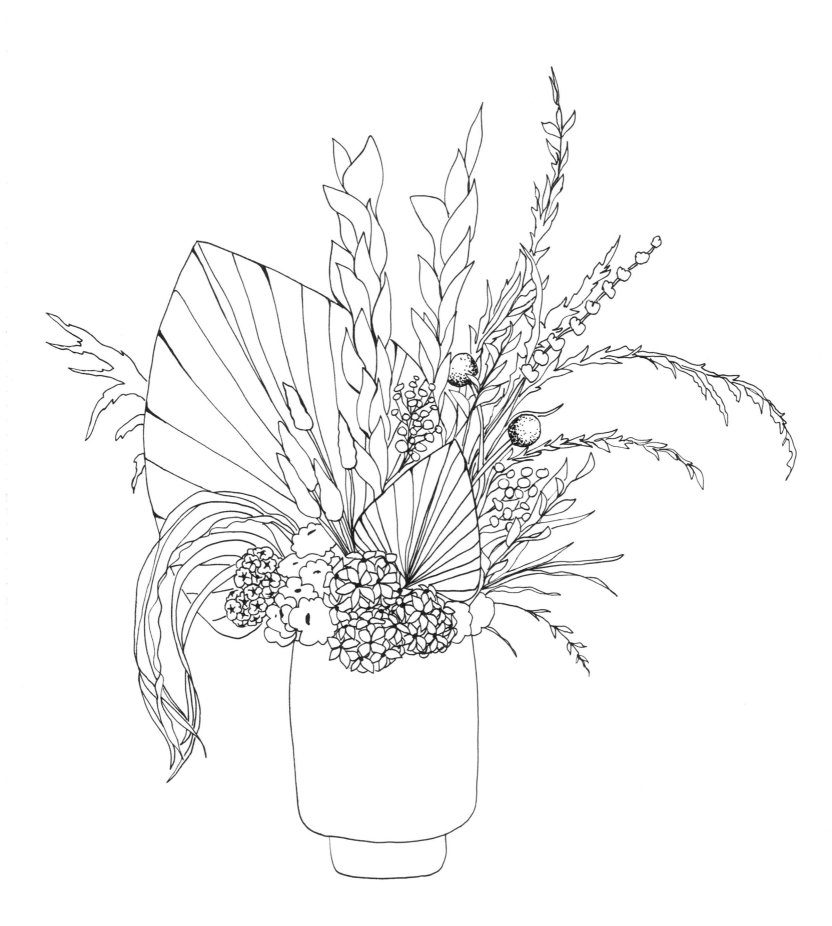

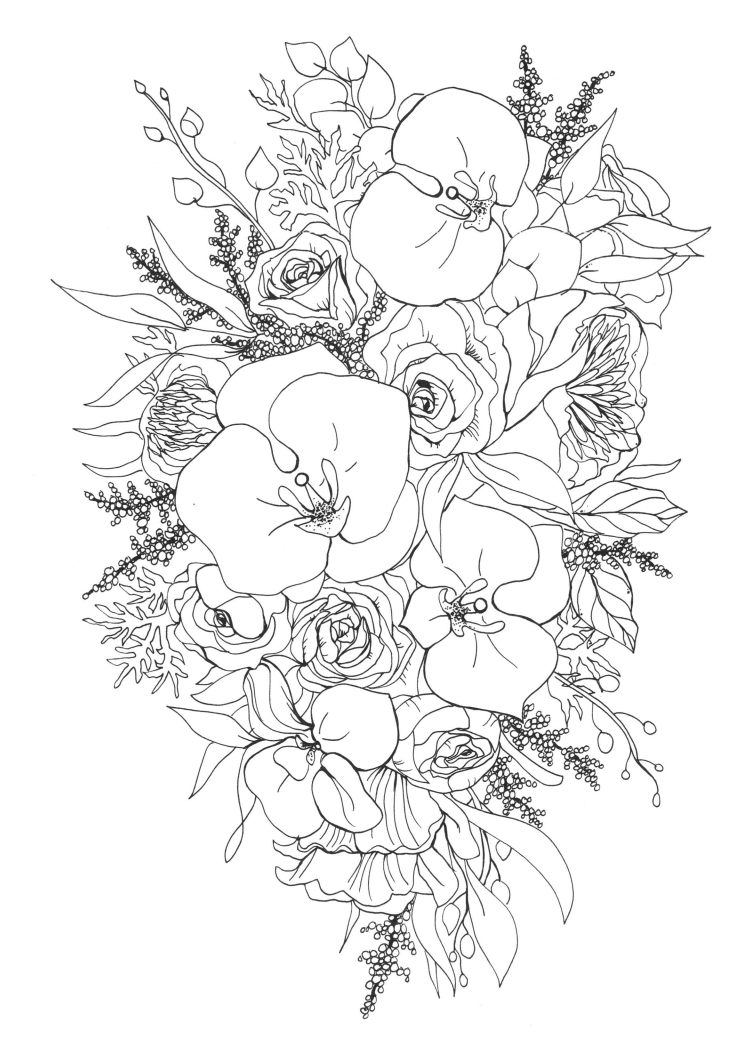

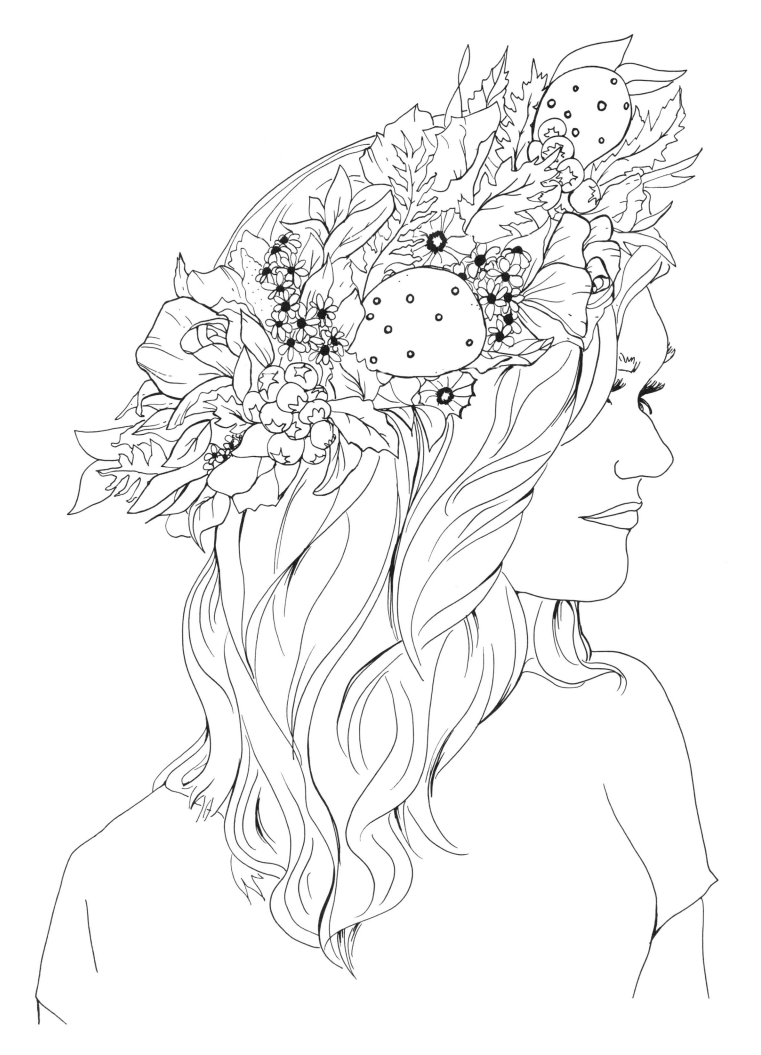

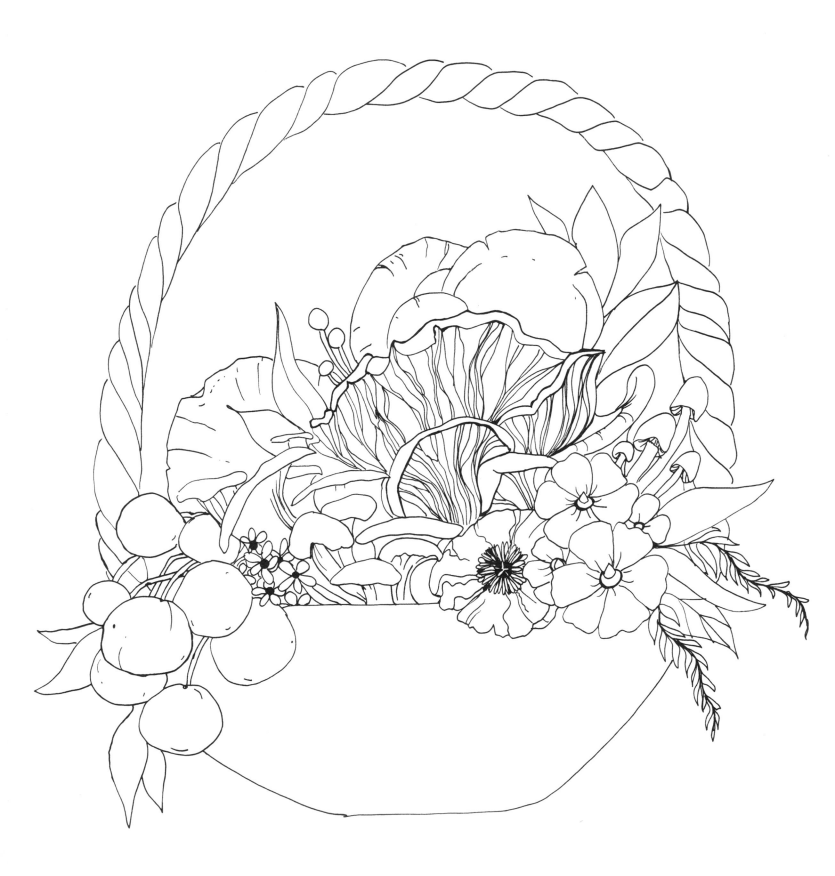

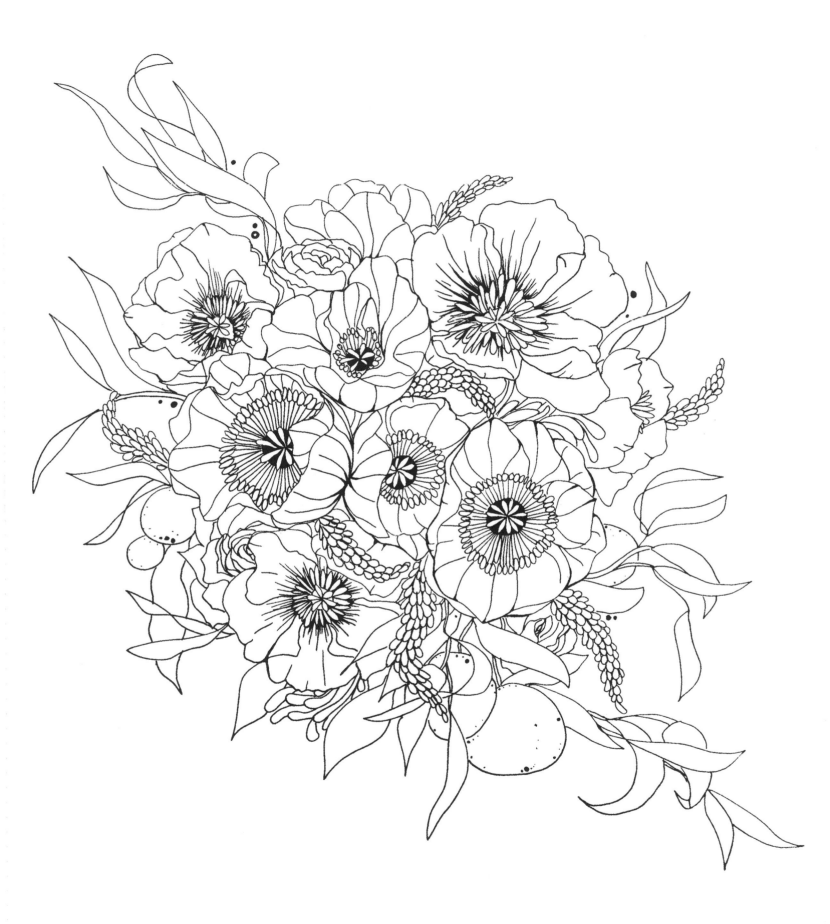

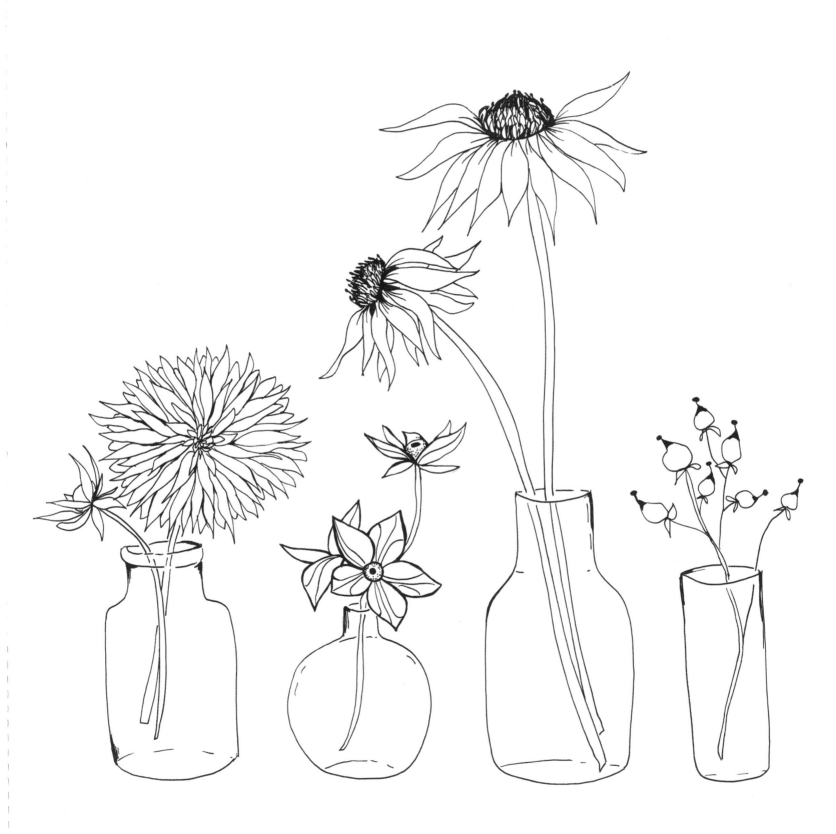

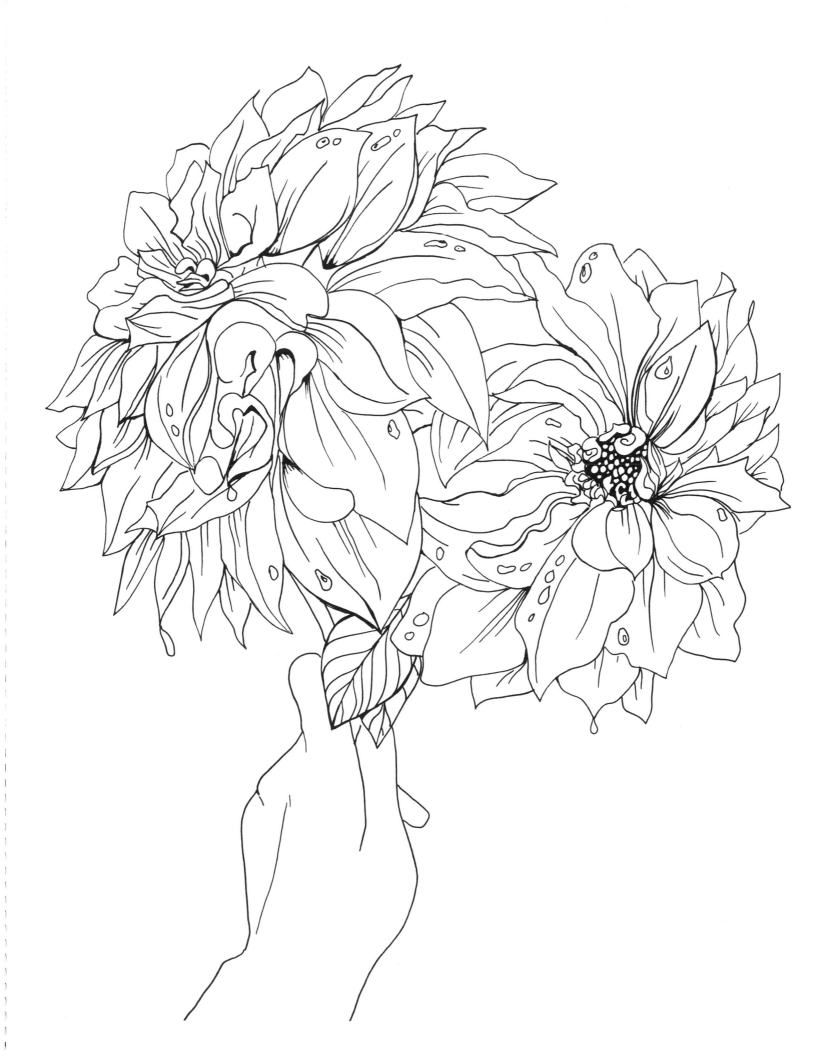

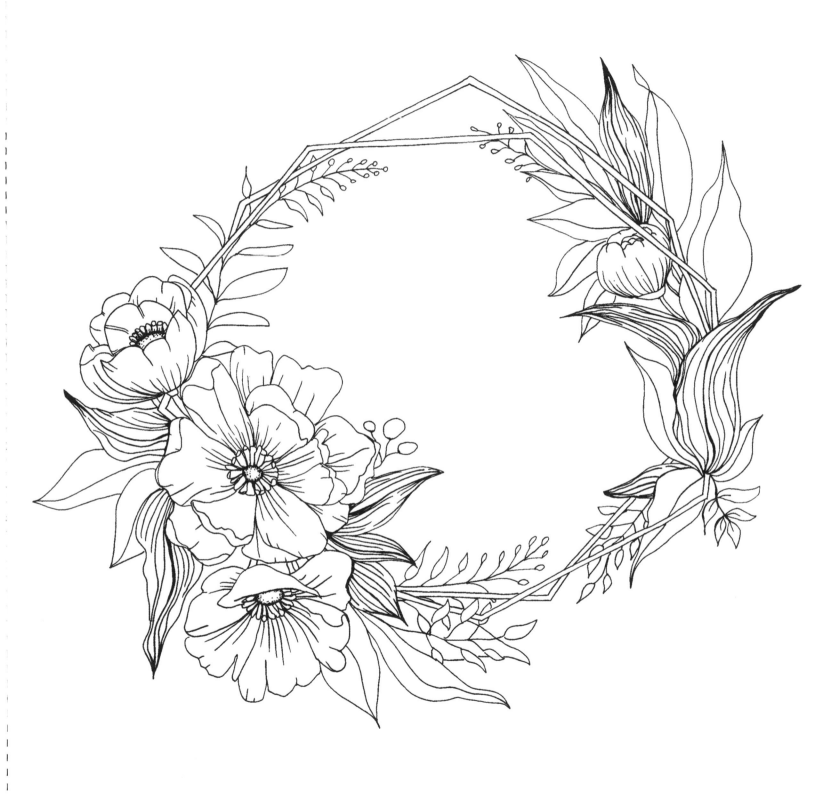

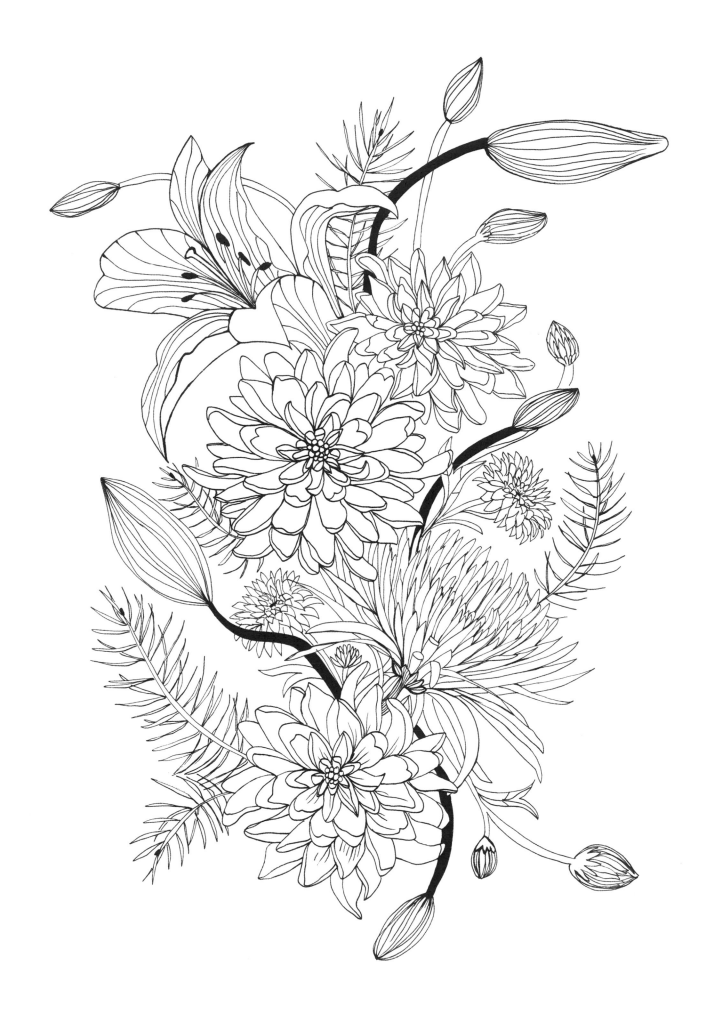

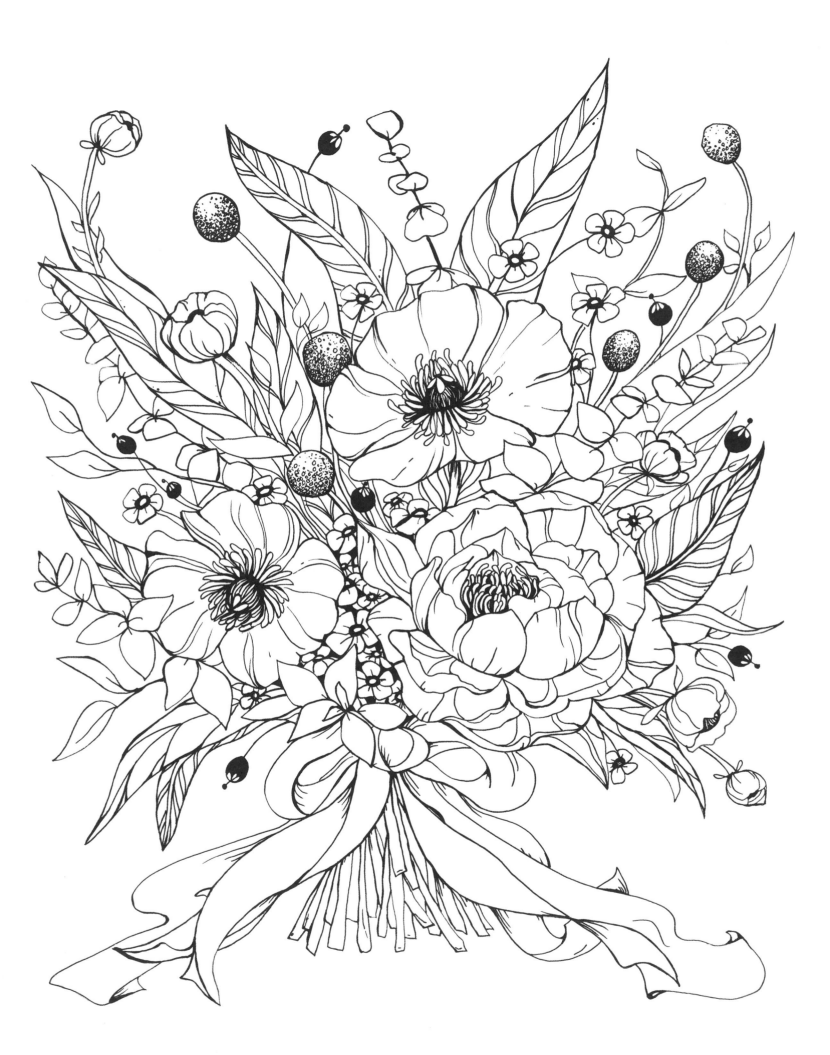

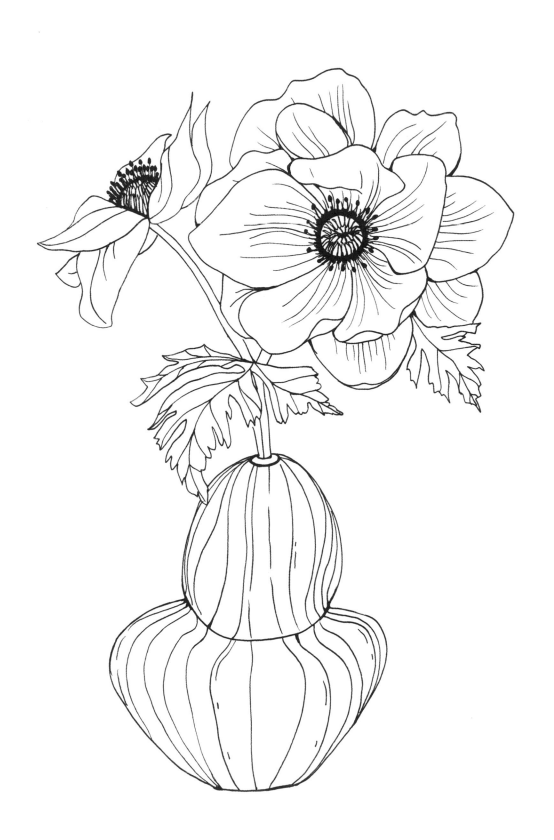

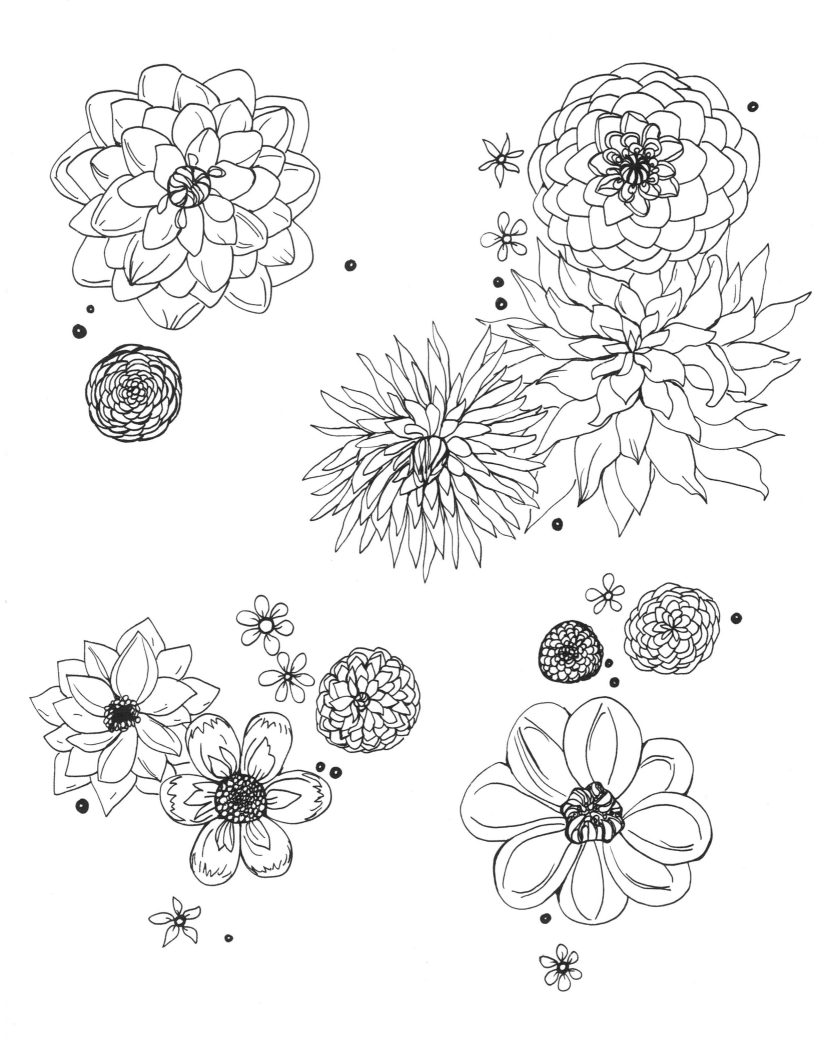

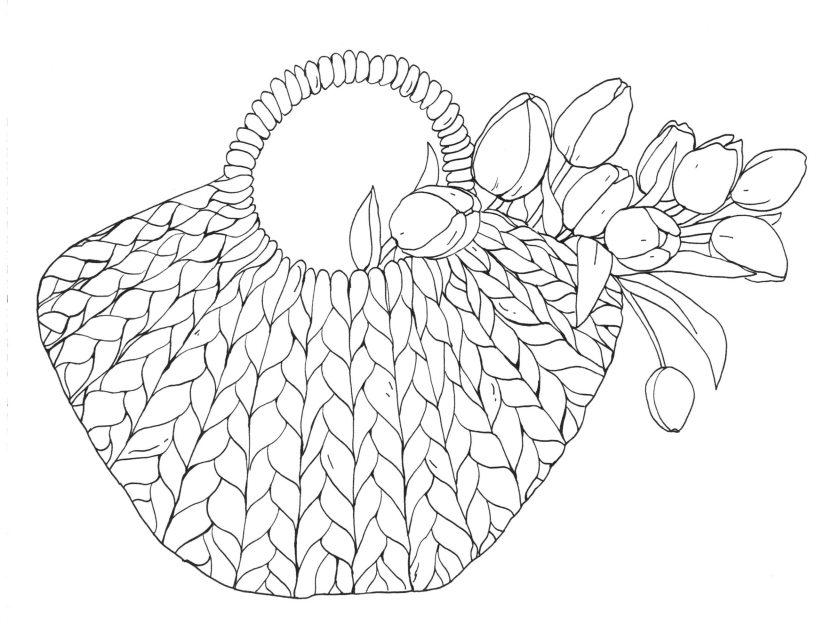

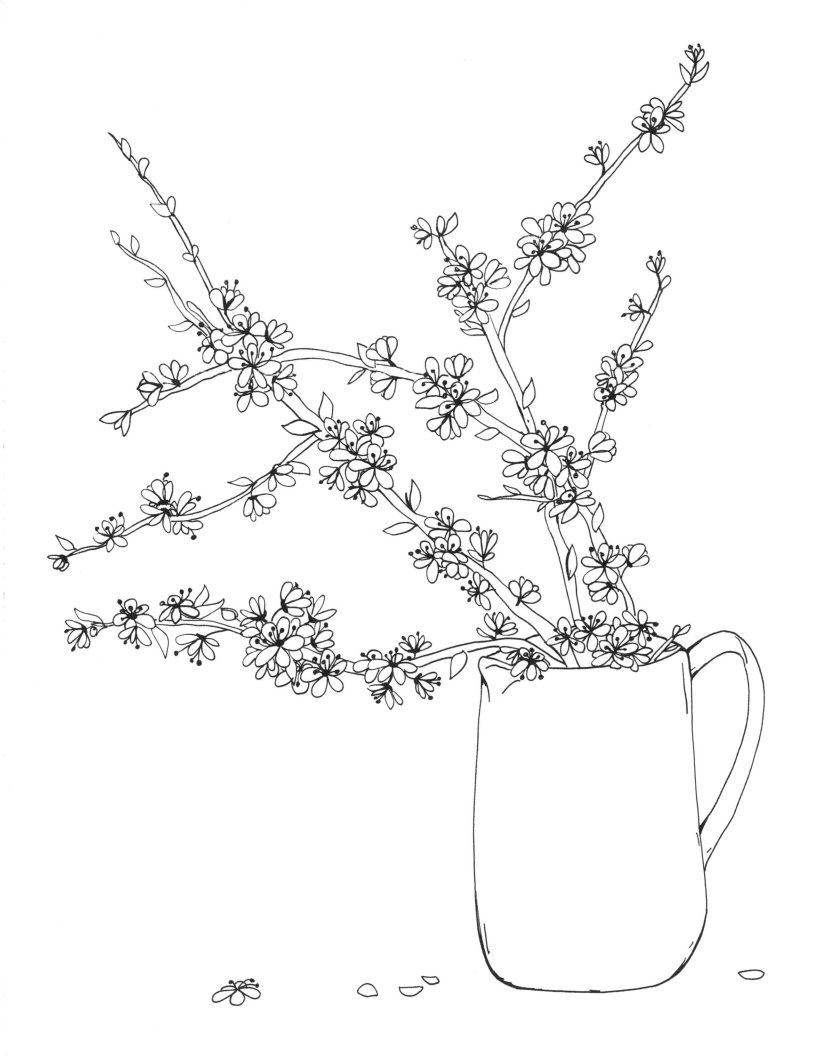

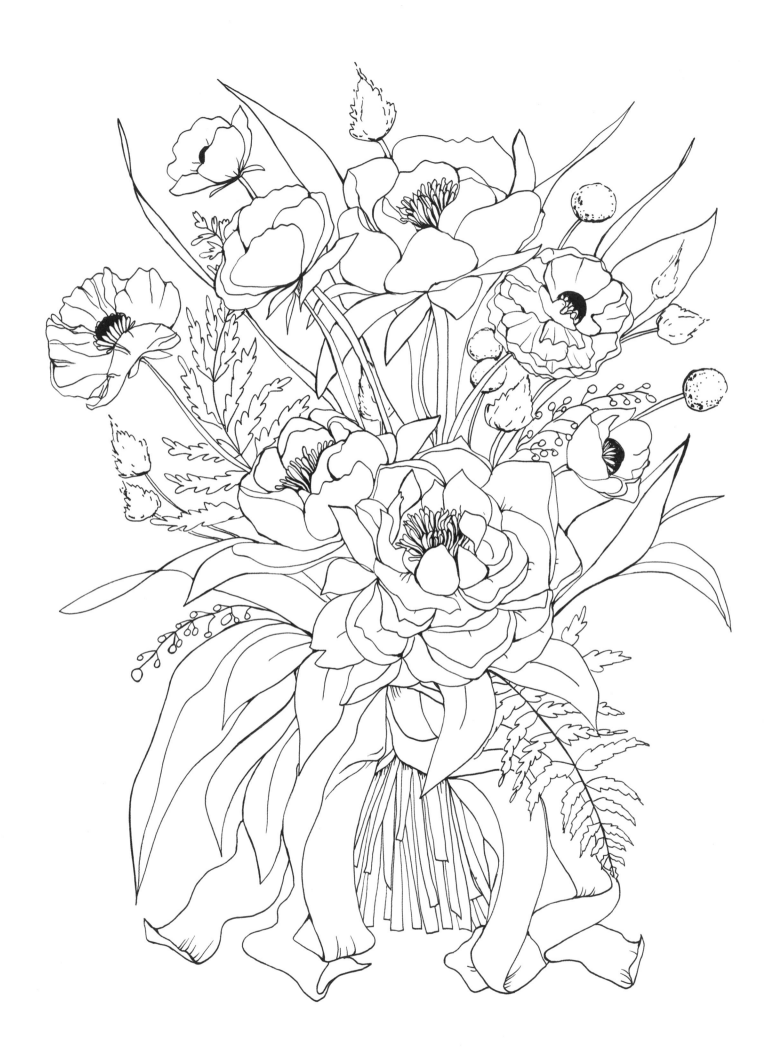

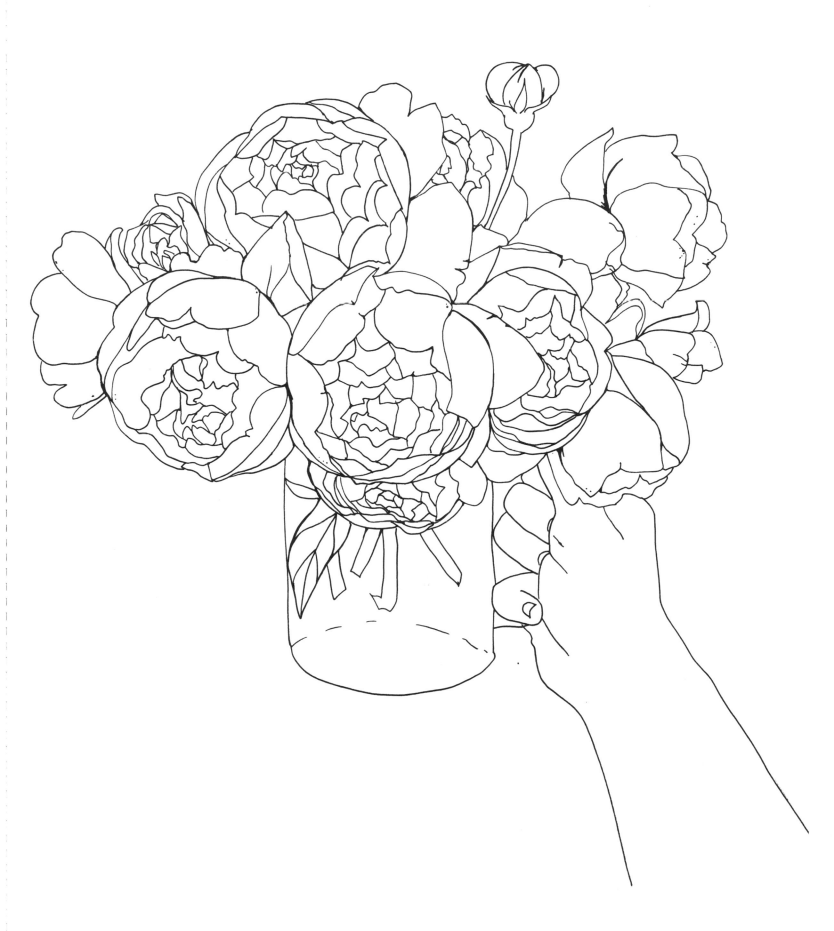

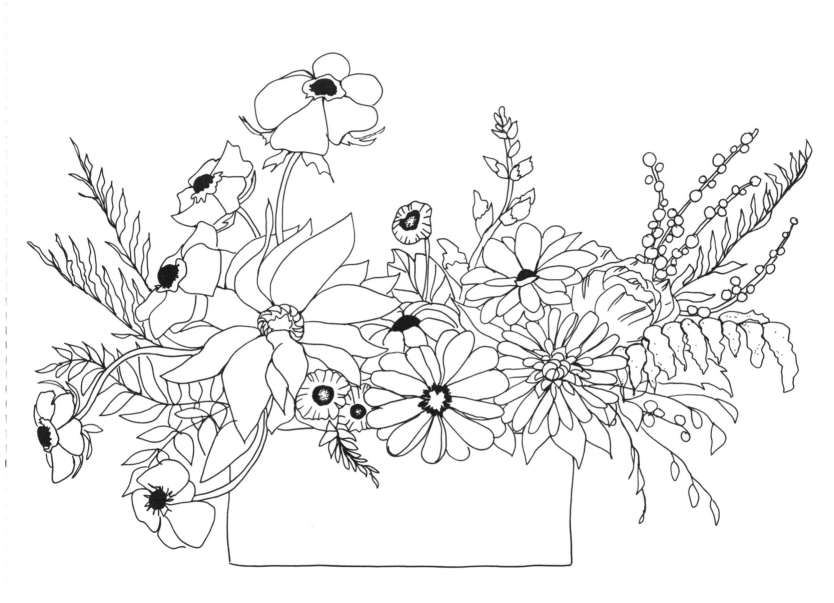

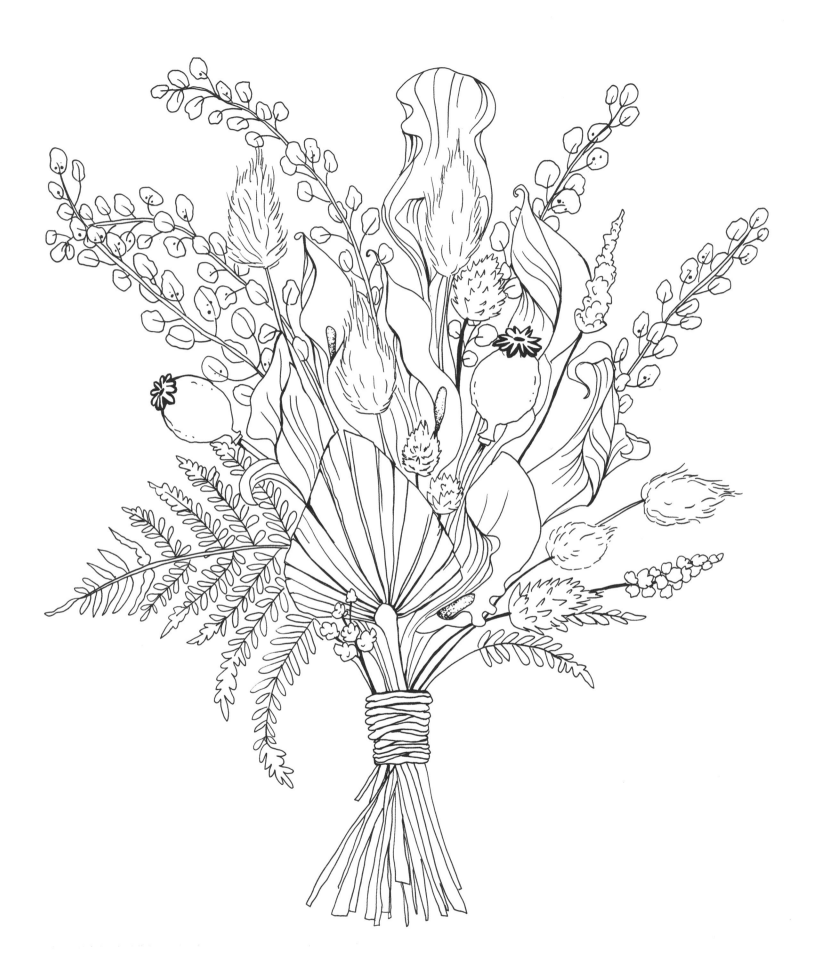

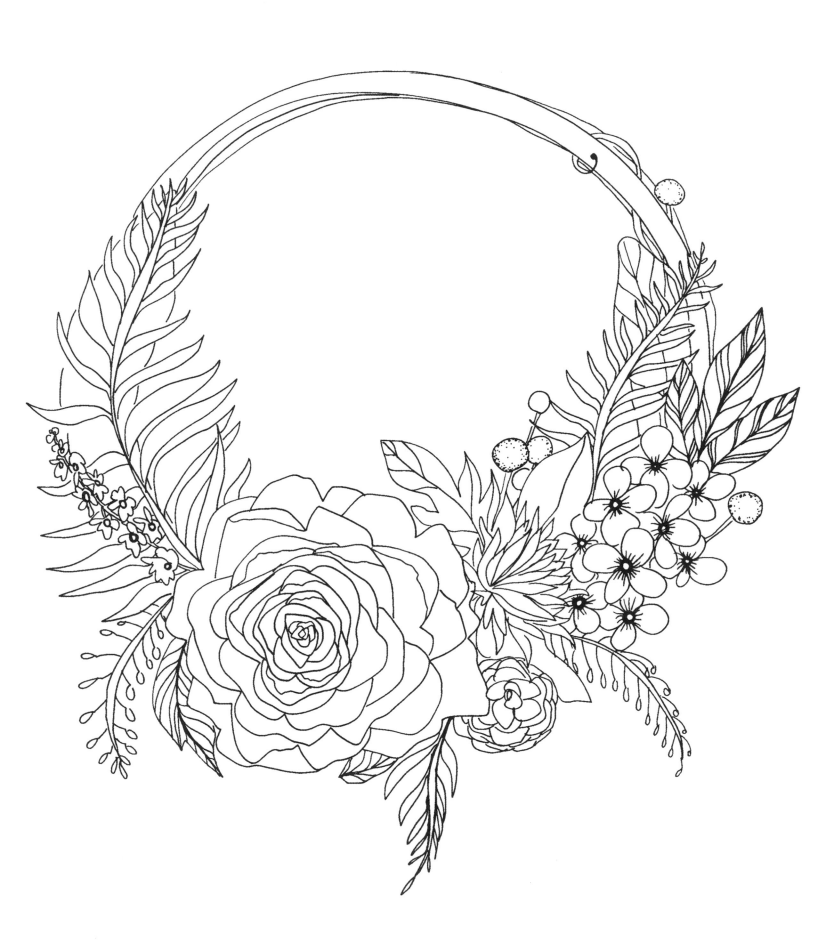

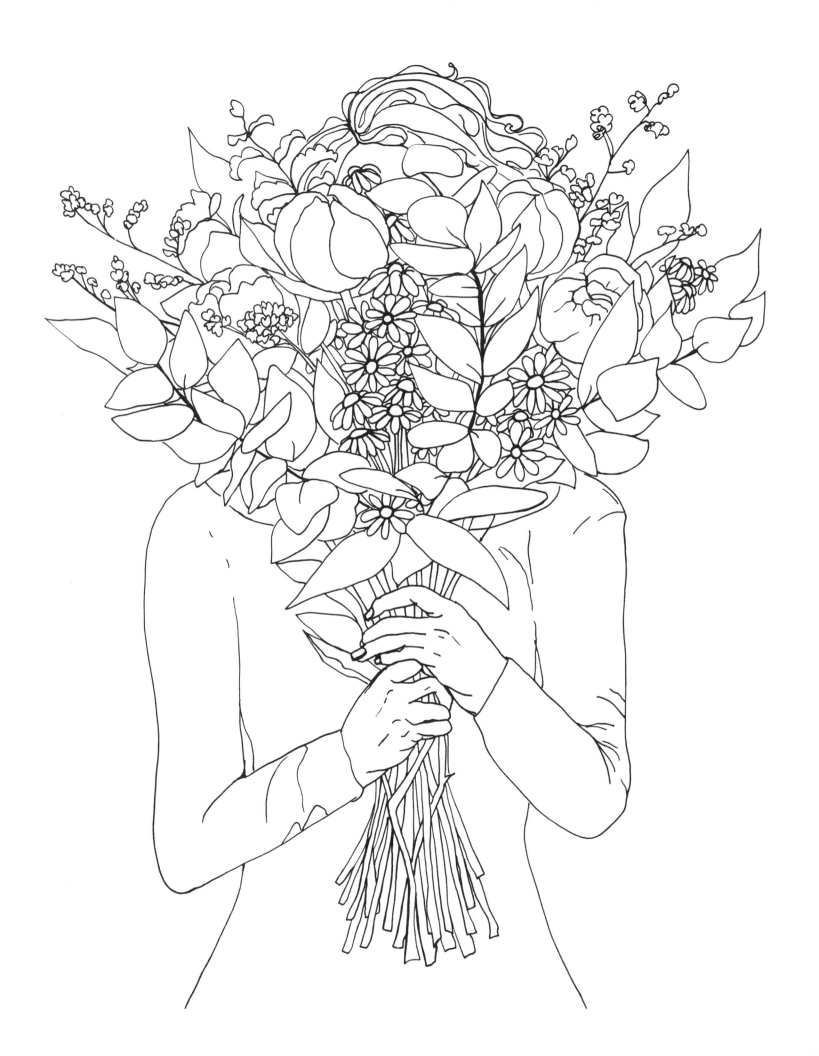

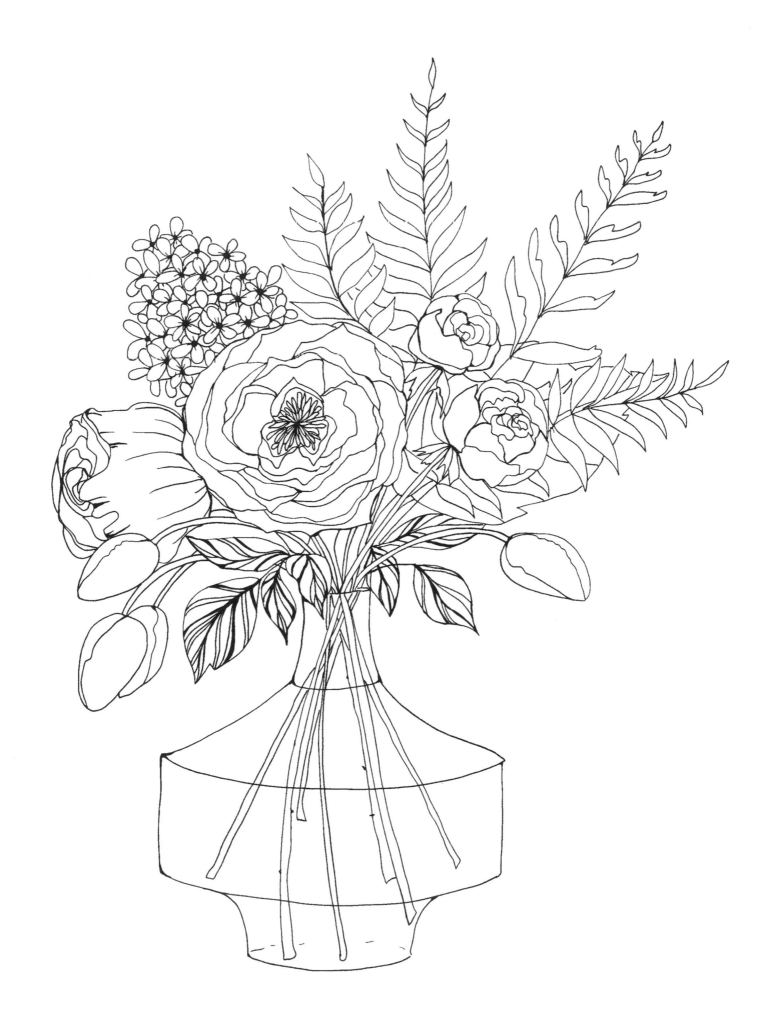

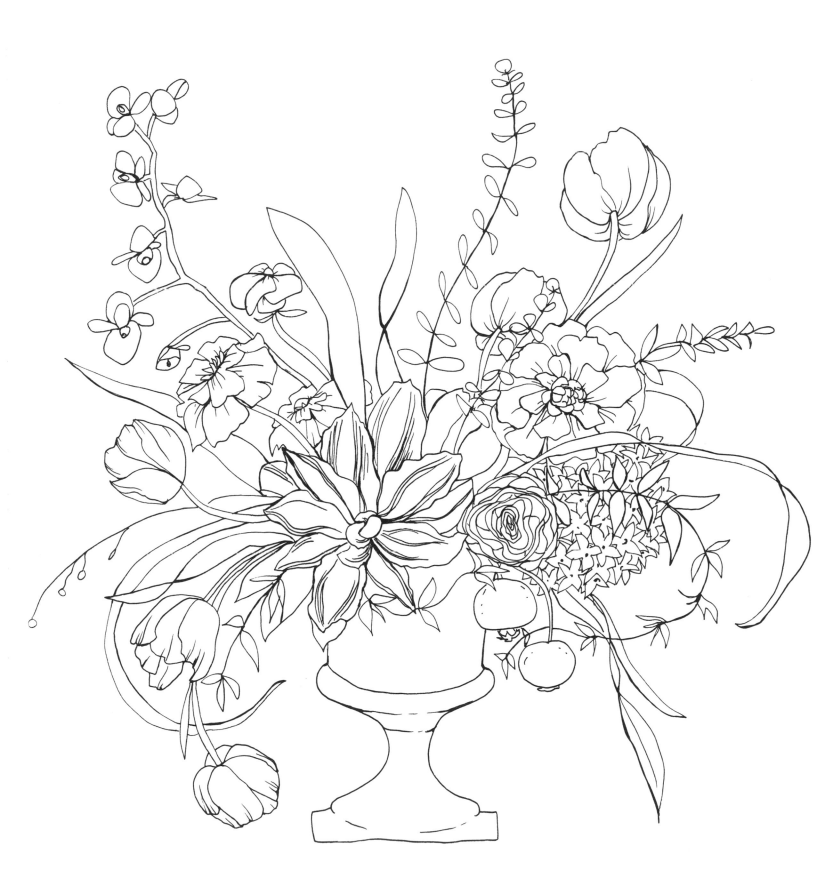

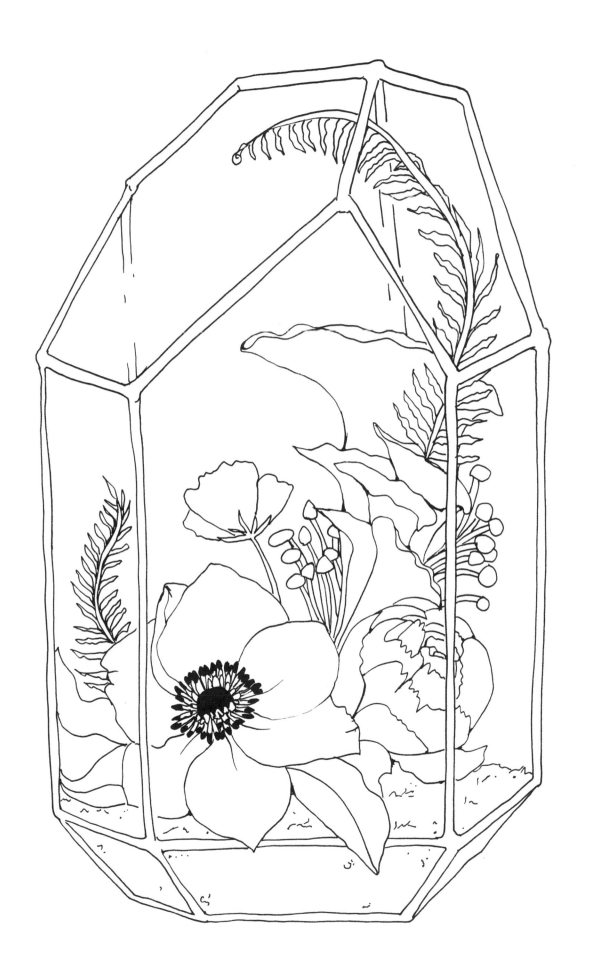

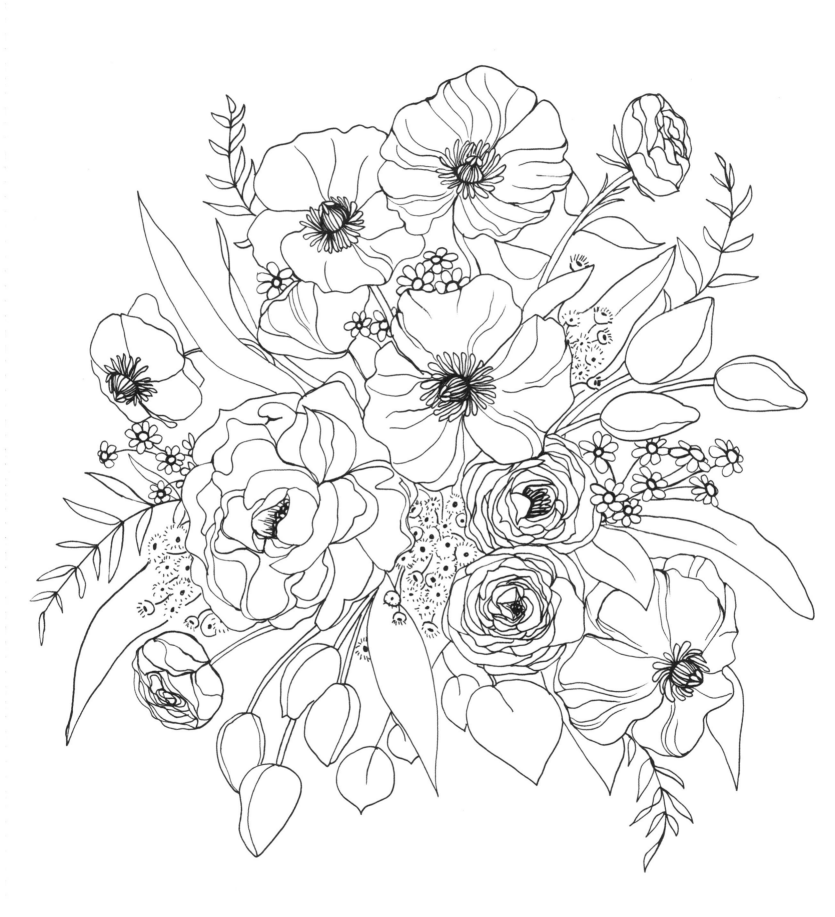

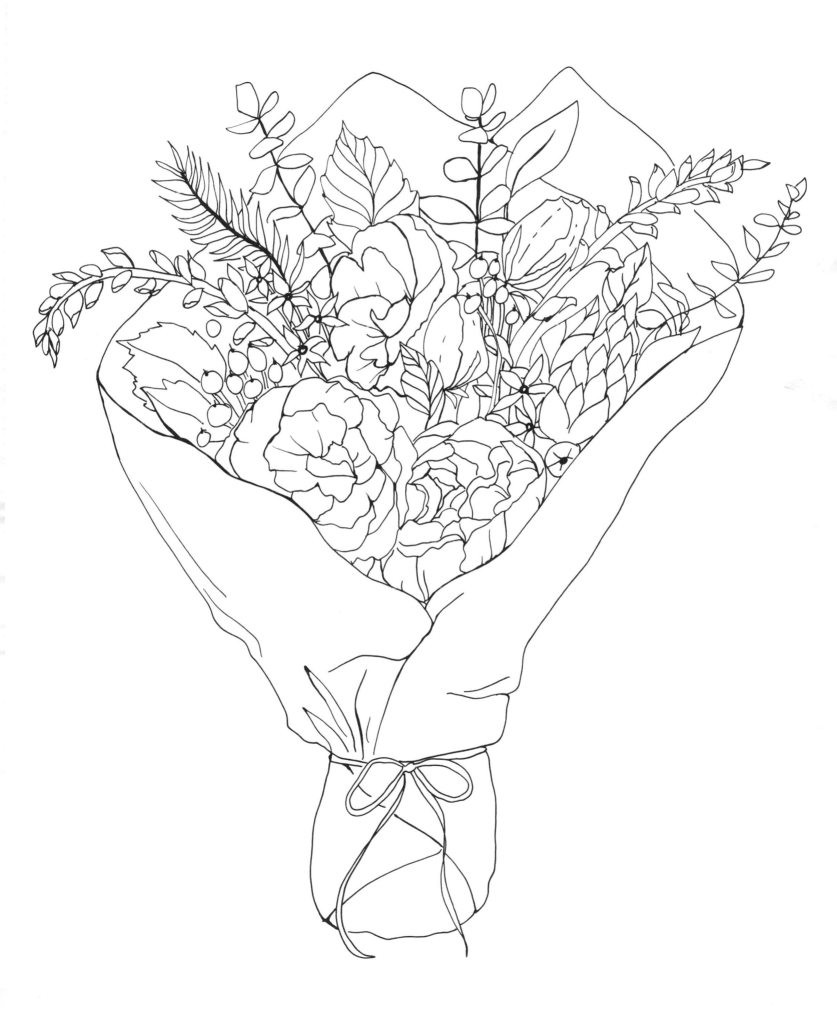

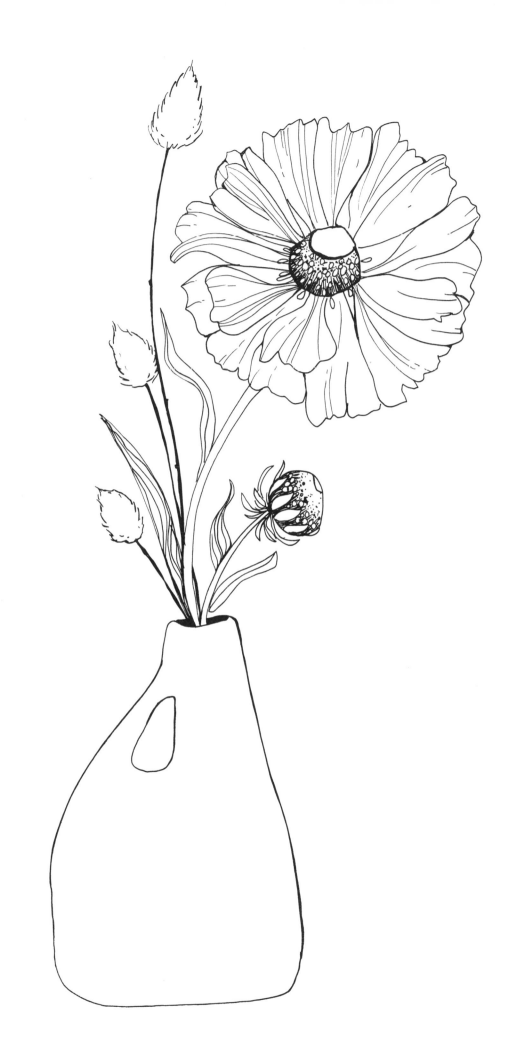

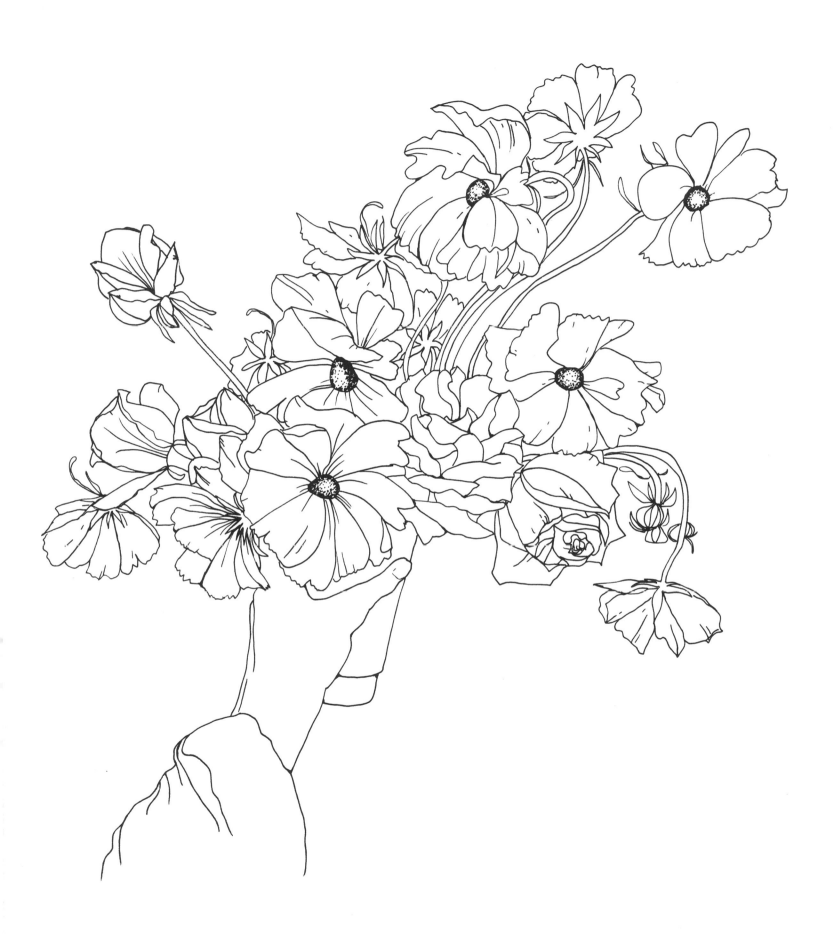

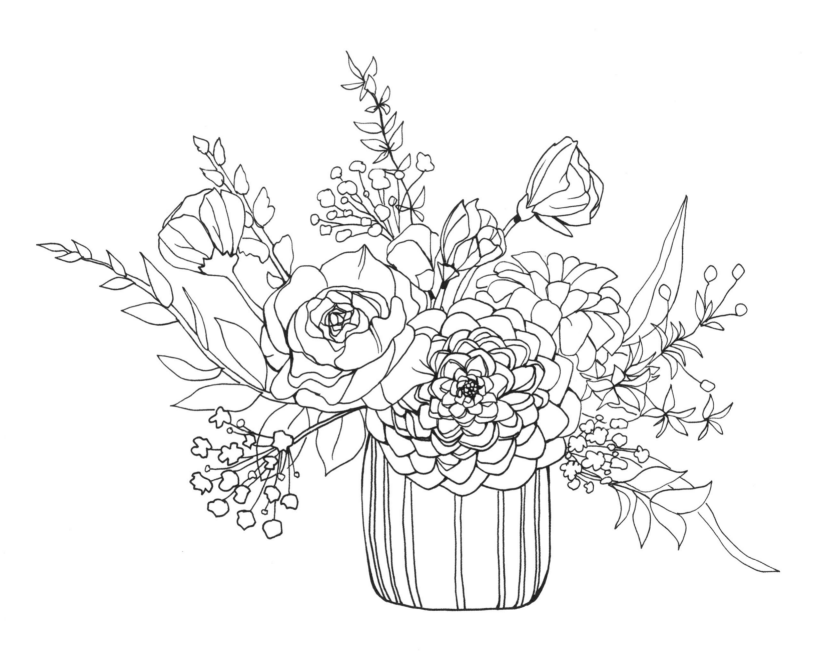

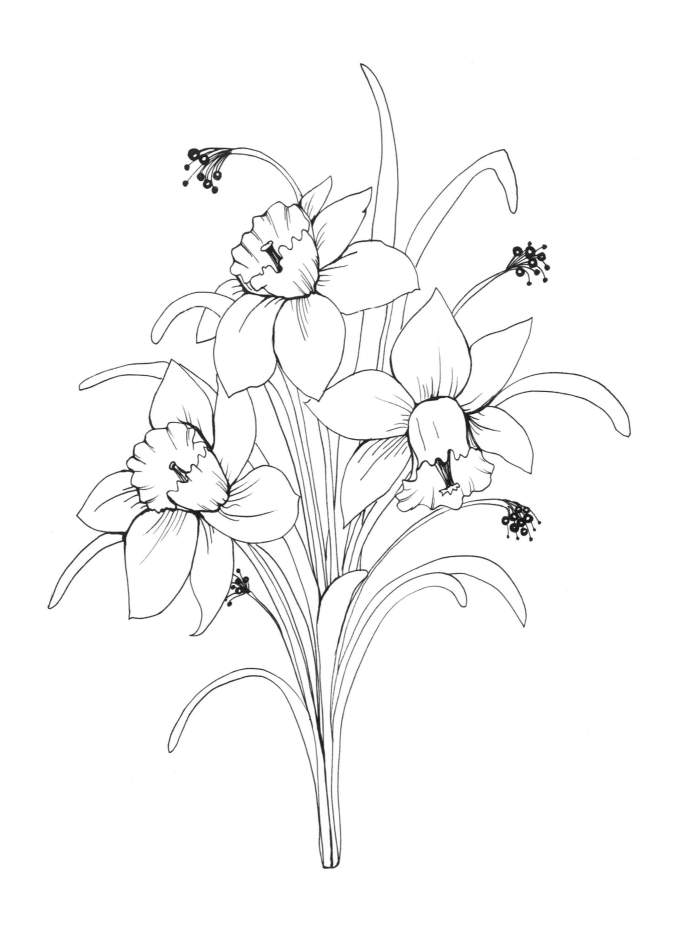

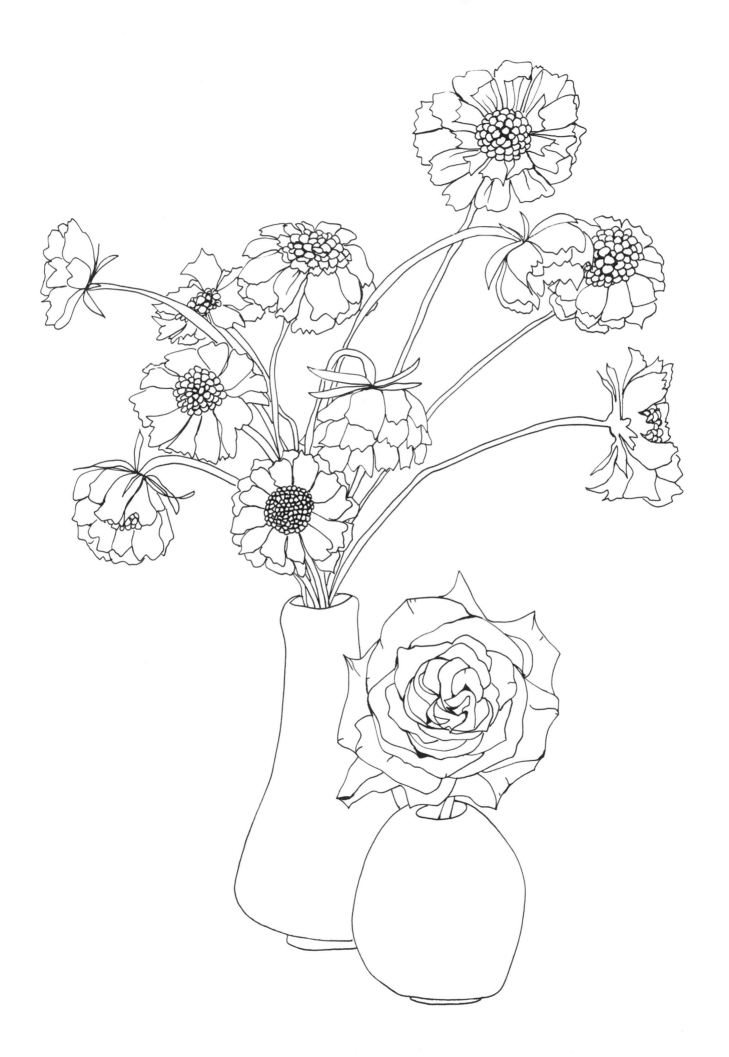

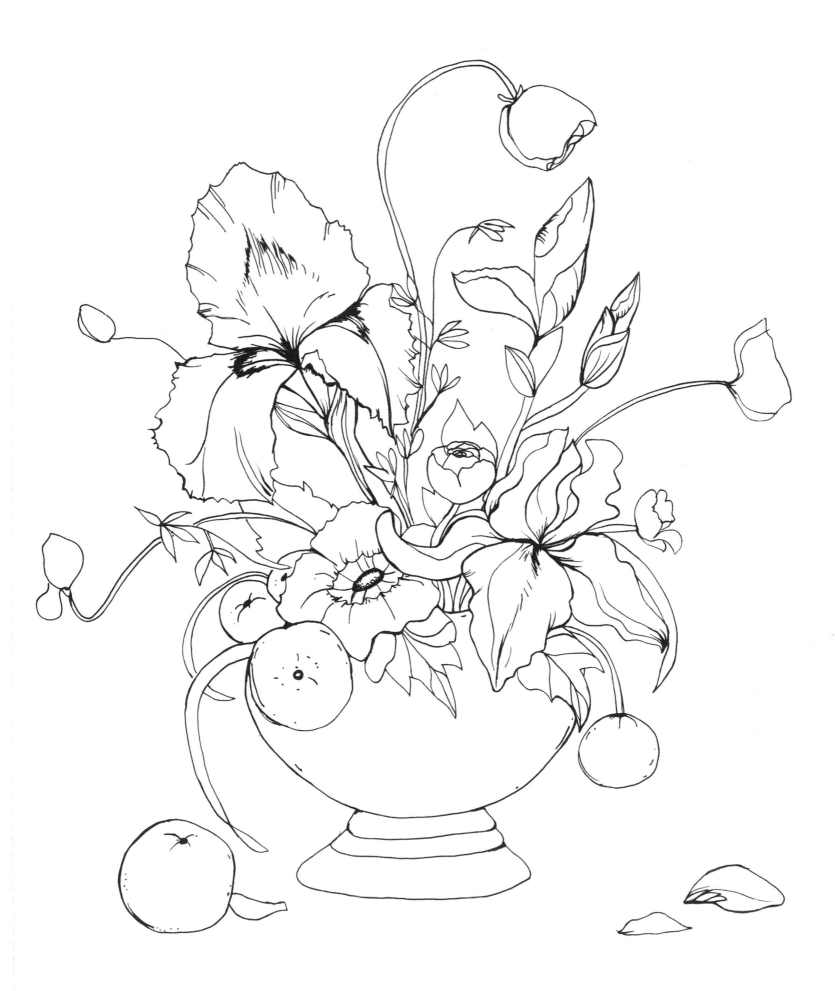

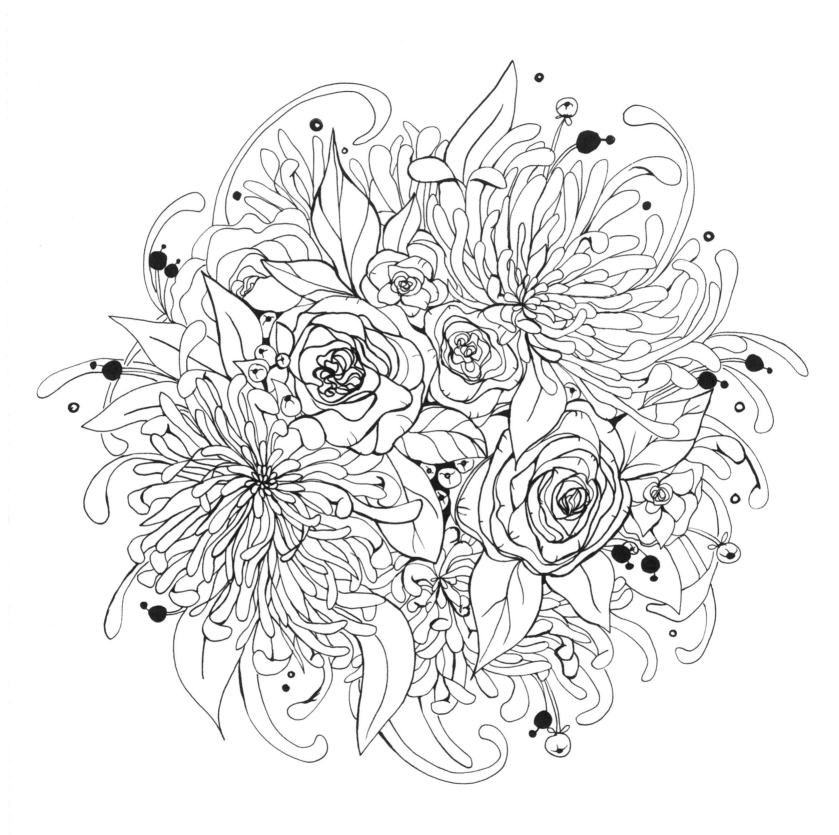

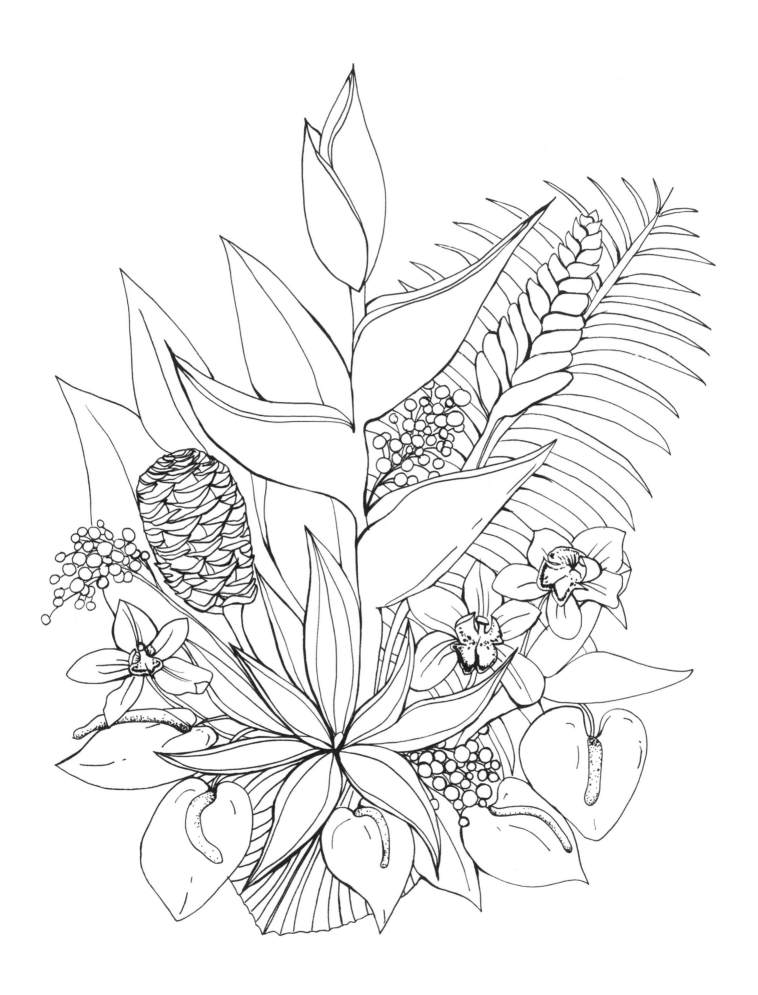

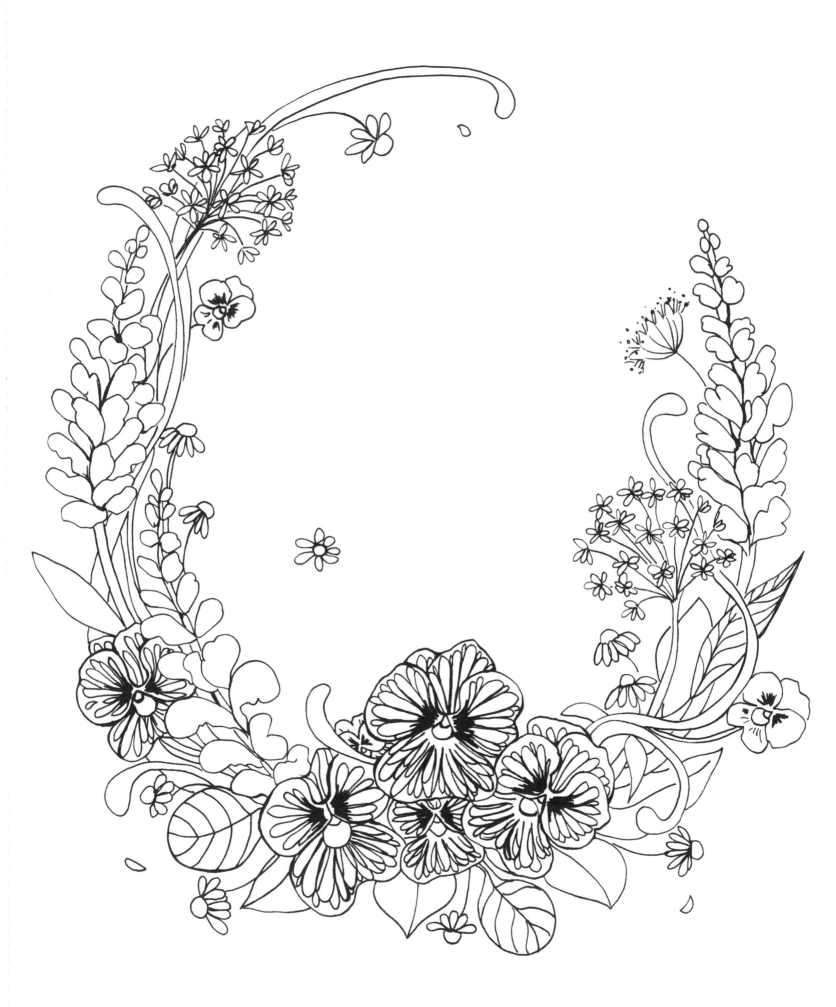

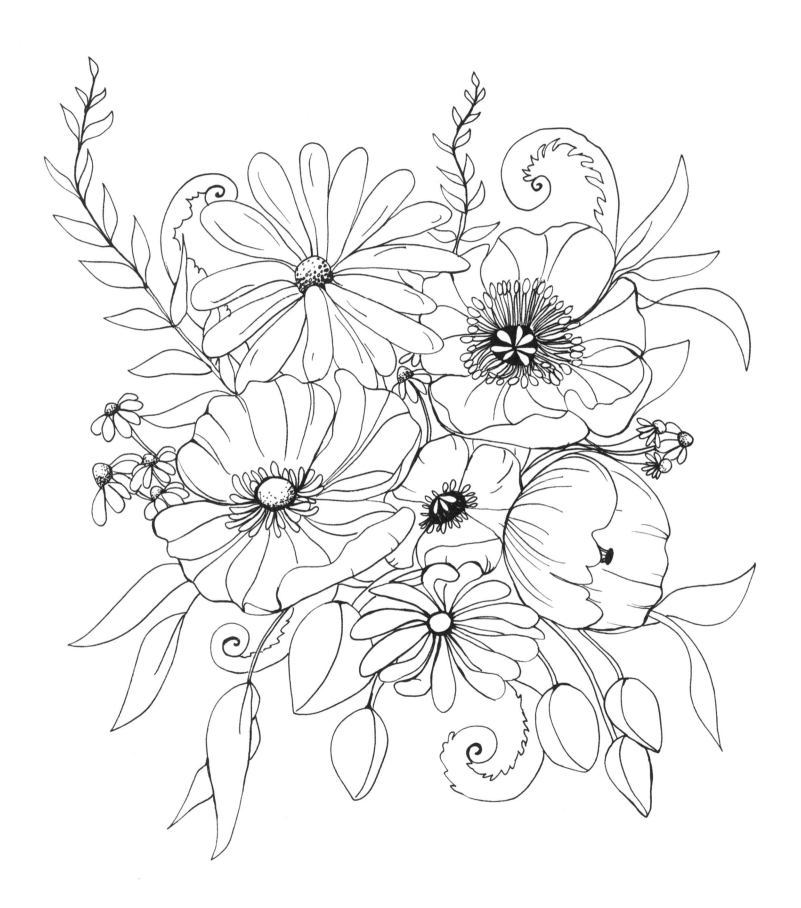

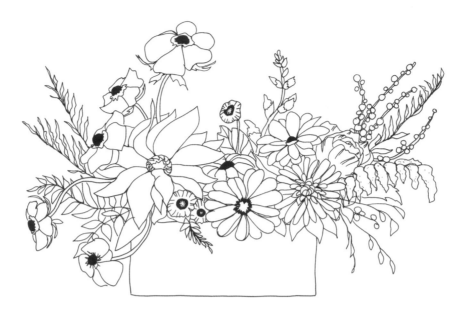

ACKNOWLEDGMENTS

*I want to thank my friend Michaela
(@thebaybarngarden on Instagram) for
providing me with artistic and floral
inspiration and still lifes to draw from.
I also want to thank my friend Alisha
(@fortheloveoffloral on Instagram), a local
florist and designer, for allowing me to
draw her beautiful arrangements.*